dream draw design

MY GARDEN

dream draw design

MY GARDEN

A SKETCHBOOK FOR GARDENERS, ARTISTS, AND LANDSCAPE LOVERS

JAMES HOBBS

Rockport Publishers
100 Cummings Center, Suite 406L
Beverly, MA 01915
rockpub.com • rockpaperink.com

© 2015 by Rockport Publishers

First published in the United States of America in 2015 by
Rockport Publishers, a member of
Quarto Publishing Group USA Inc.
100 Cummings Center
Suite 406-L
Beverly, Massachusetts 01915-6101
Telephone: (978) 282-9590
Fax: (978) 283-2742
www.rockpub.com
Visit RockPaperInk.com to share your opinions, creations, and passion for design.

10 9 8 7 6 5 4 3 2 1

ISBN: 978-1-63159-042-9

Digital edition published in 2015
eISBN: 978-1-62788-361-0

Library of Congress Cataloging-in-Publication Data available.

Design: Debbie Berne
Cover Image: James Hobbs

Printed in China

This book is dedicated to the memory of my
mother, Mary Hobbs, who adored her gardens, and
spent many happy, sunny hours shaping them.

CONTENTS

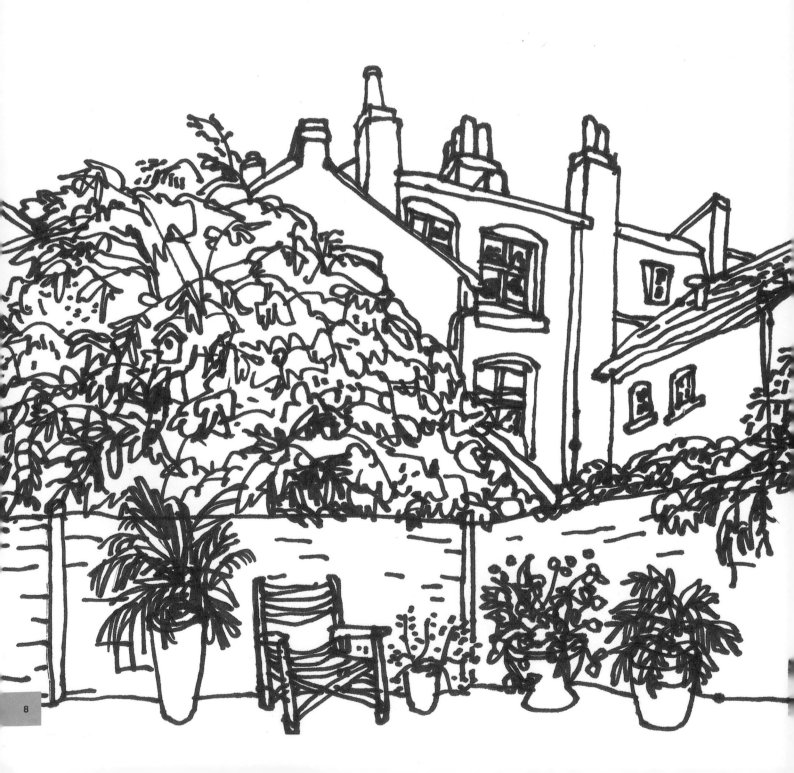

INTRODUCTION

Our dream garden: We can see it in our imagination, but can we get it on paper and perhaps even into reality? Those dreams may be of pots and containers in a humble backyard, of simple window boxes for an apartment, of a journey through flower beds from the street to your front door, of a roof-top terrace overlooking the city, or of exotic shrubs, trees, and lawns in a large, sun-filled garden.

This book guides your imagination toward designing that dream garden through unfinished images and suggestions of ideas and themes that you can draw. Take whatever medium you like—pencils, pens, inks, colored pencils, watercolor—and explore these themes by drawing over them and around them, taking them in whatever direction you like. The aim is not to fill the white space on each page with "perfect" drawings, or to emulate any style, but to unleash your gardening imagination, to experiment and play your way toward a vision of your ideal garden design. Some pages may lead you in directions you have never thought of taking, others may make you change those dreams and ideas. There is no right or wrong here.

Drawing is like thinking on paper, and what you create in this book can be the first step toward making those dreams a reality.

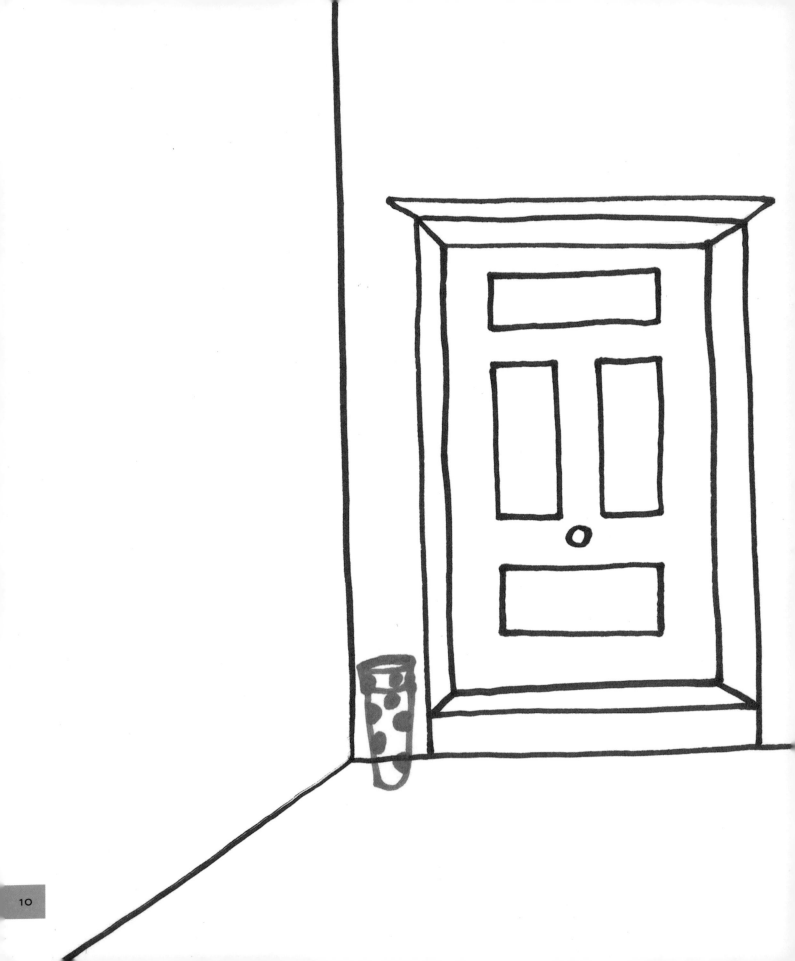

FRONT DOOR

This front door lies at the end of a dull, gray alleyway. Enliven the walk to its doorstep with lighting, containers, and color. What about stained glass windows?

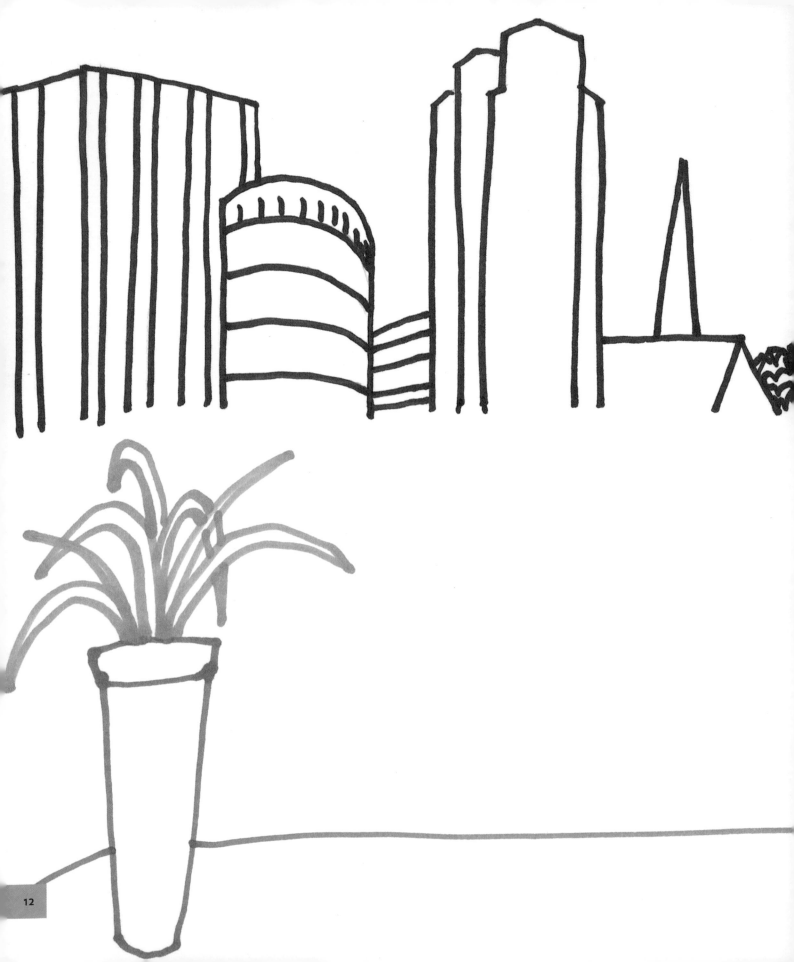

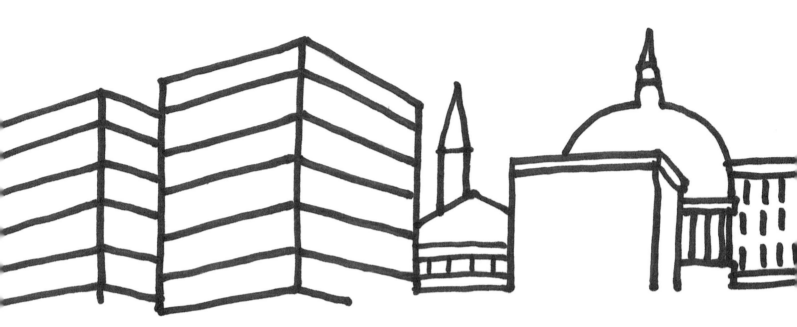

ROOF DECK SKYLINE

Looking for calmness and greenery in the city?
Design a refuge in the sky to sit and relax in
overlooking this view.

OPEN DOORS

Gardens don't just exist outside. Let the garden flow into your home through these open doors. And try drawing your own on this page.

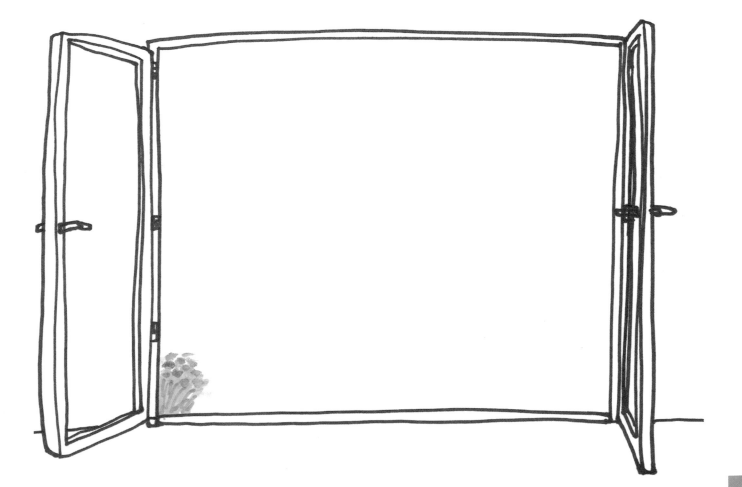

VERTICAL GARDEN

Planting vertically—up the side of a wall—can bring nature and growth to the most space-starved urban environment. Bring this stark, concrete building to life with greenery.

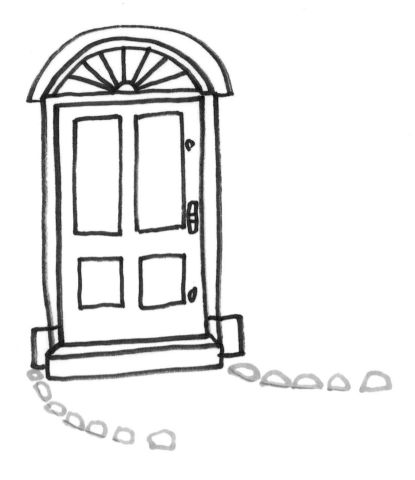

PATH TO A DOOR

The walk up the path is the introduction to a house. Soften, enliven, and bring color to the journey to welcome people to this door.

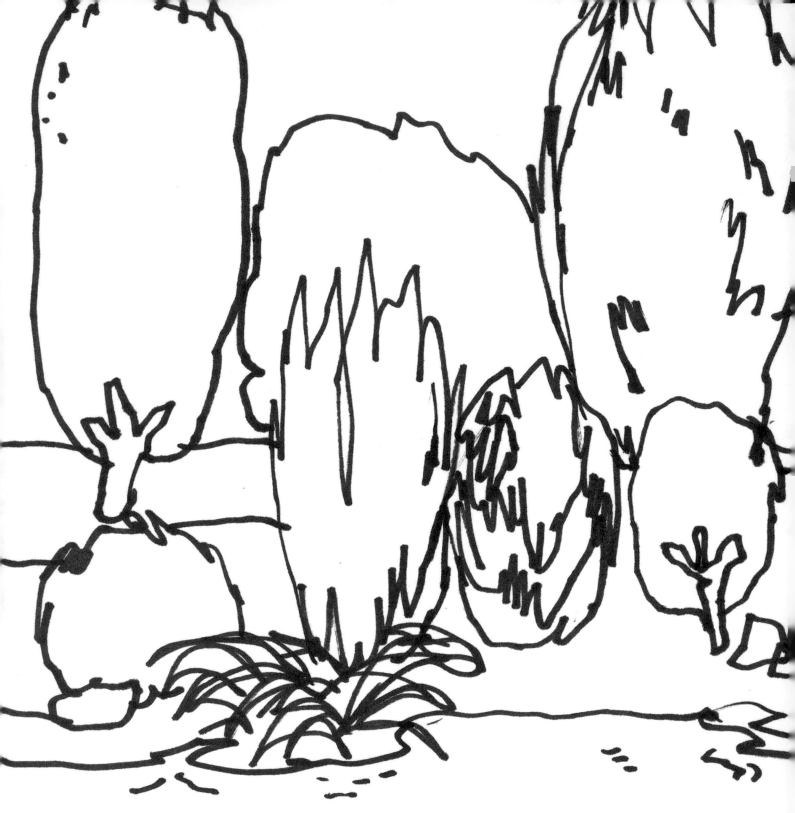

FALL COLORS

Fall colors: there is nothing like them. Bring a
range of reds, yellows, browns, and purples to
these trees and shrubs along the water's edge.

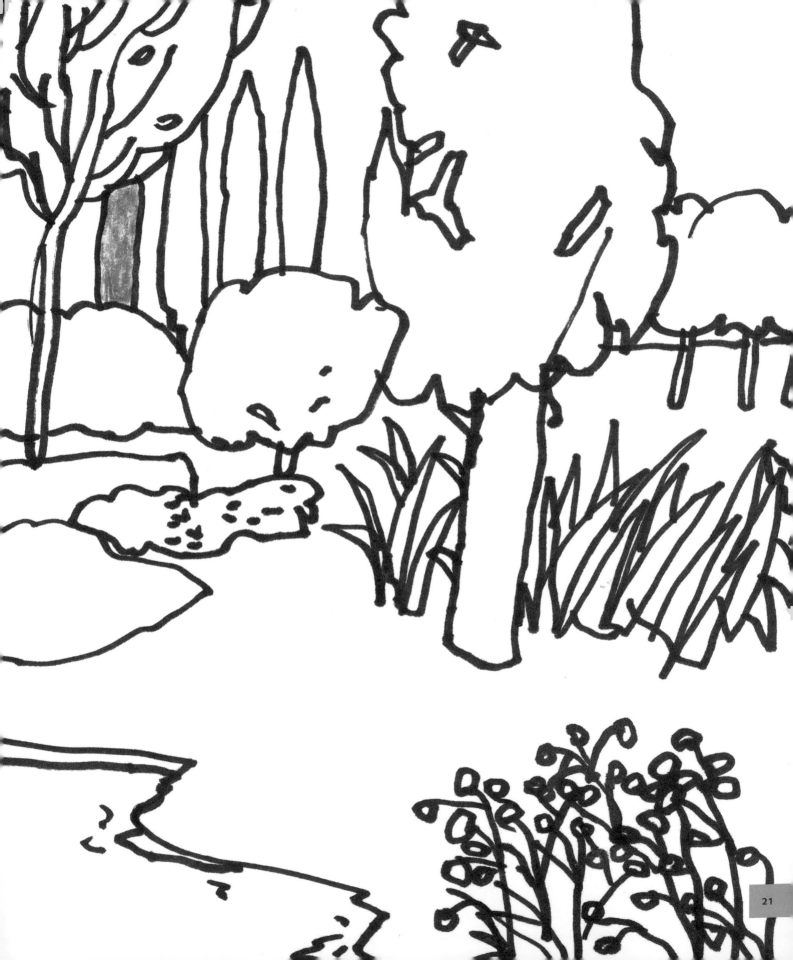

PAVED GARDEN

Why pave over your front yard and turn it into a parking lot when you can have an oasis of calm and greenery instead? Bring this expanse of paving back to life.

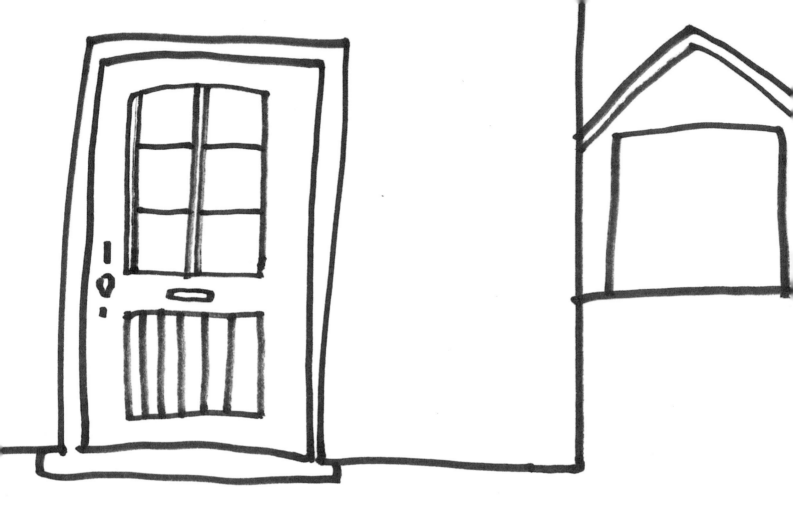

SITTING COMFORTABLY

Garden seating doesn't have to be hard and formal. Create a cozy retreat to relax in with friends, a book, or music. Focus on comfort and a calming display of plants.

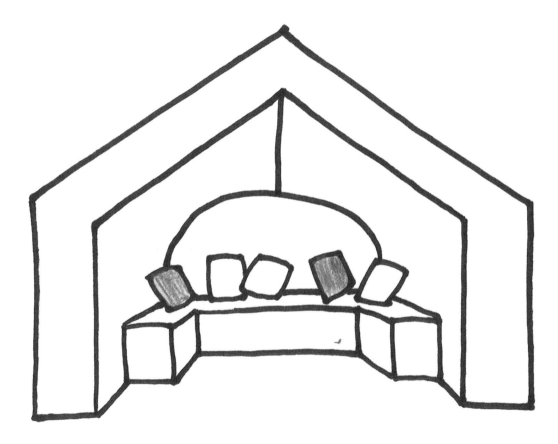

THE GARDEN OF A BUNGALOW

What is in the backyard of this bungalow?

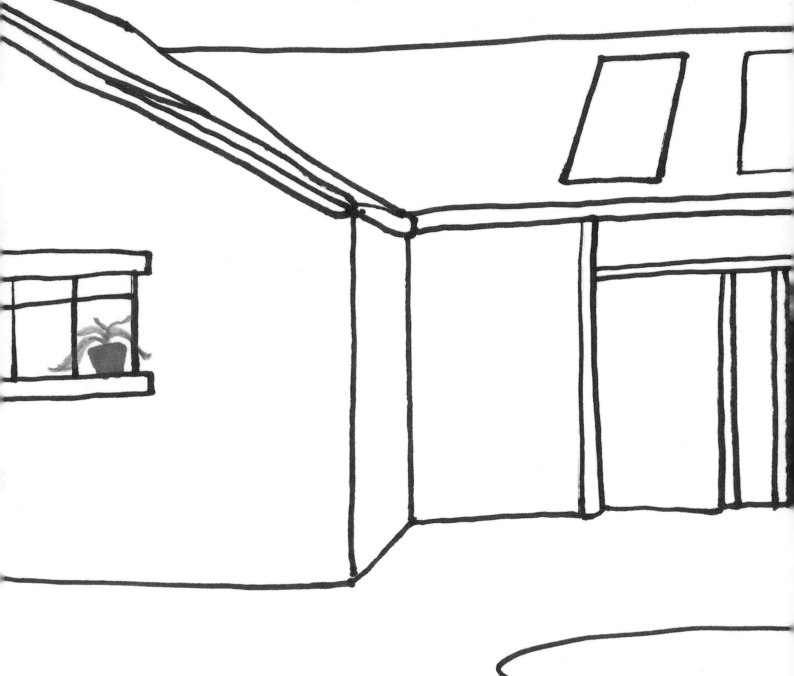

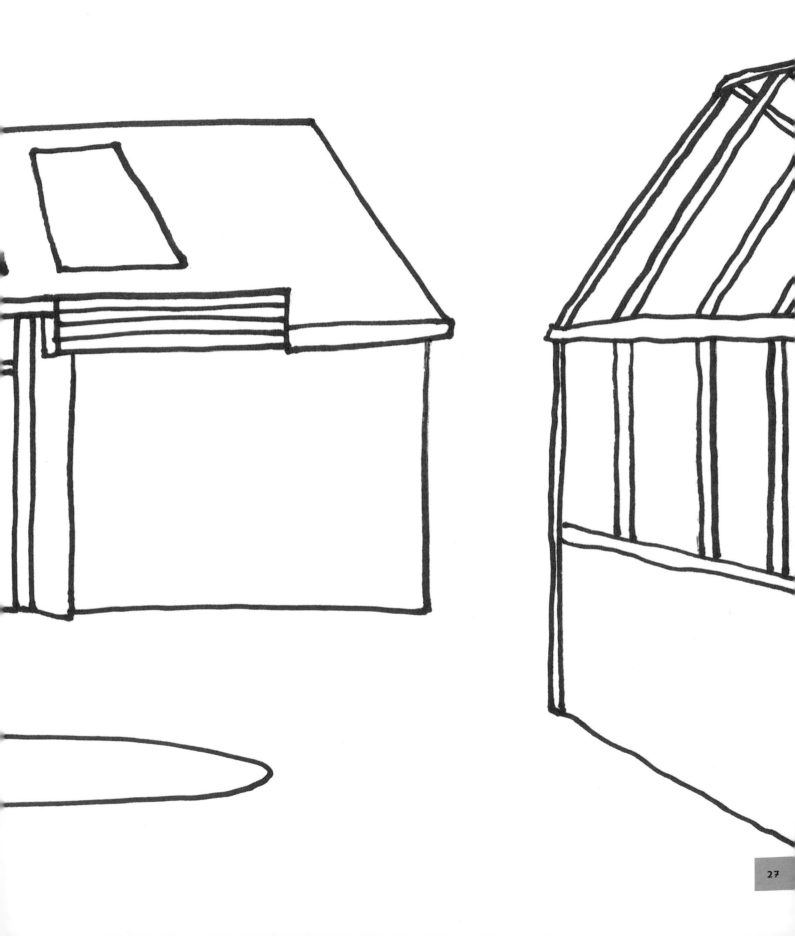

FOUNTAINS

What are these plumes of water springing from?
One fountain? Three? Traditional or modern?

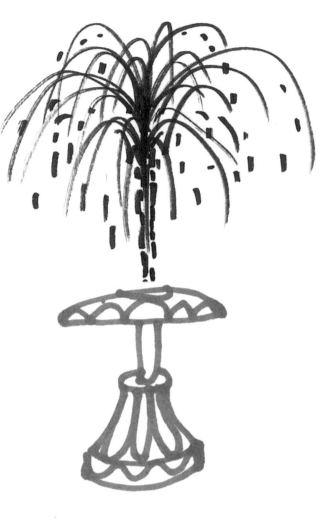

WINDOW BOXES

Your window on the world starts with a window box. But what is its shape and what is in it?

TOPIARY

Careful and well-judged use of shears can bring exotic shapes to evergreens. Design your own living garden sculptures with imaginative forms.

ROCK GARDENS

A rock garden can blend a natural setting with ornamental planting. Incorporate running water and pools to create a relaxed setting.

WATER GARDENS

A stream runs into your garden—make it the centerpiece of this design with pools, decking, rocks, and water-loving plants.

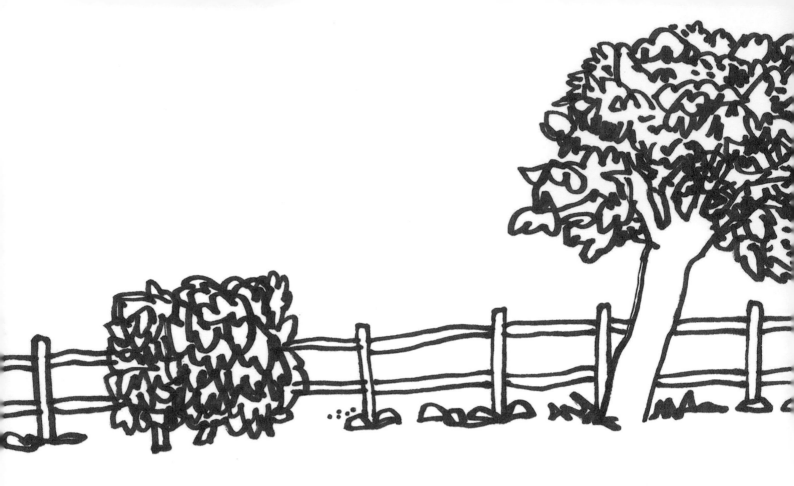

VEGETABLE GARDEN

Nothing can compare with home-grown fruit and vegetables. Plan your plot at the bottom of your garden to grow the produce you most like to eat.

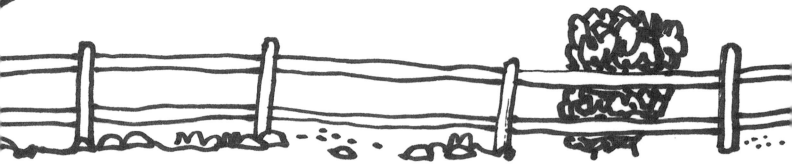

ENTRYWAY GARDEN

Breathe life into the entrance to this faded apartment block.

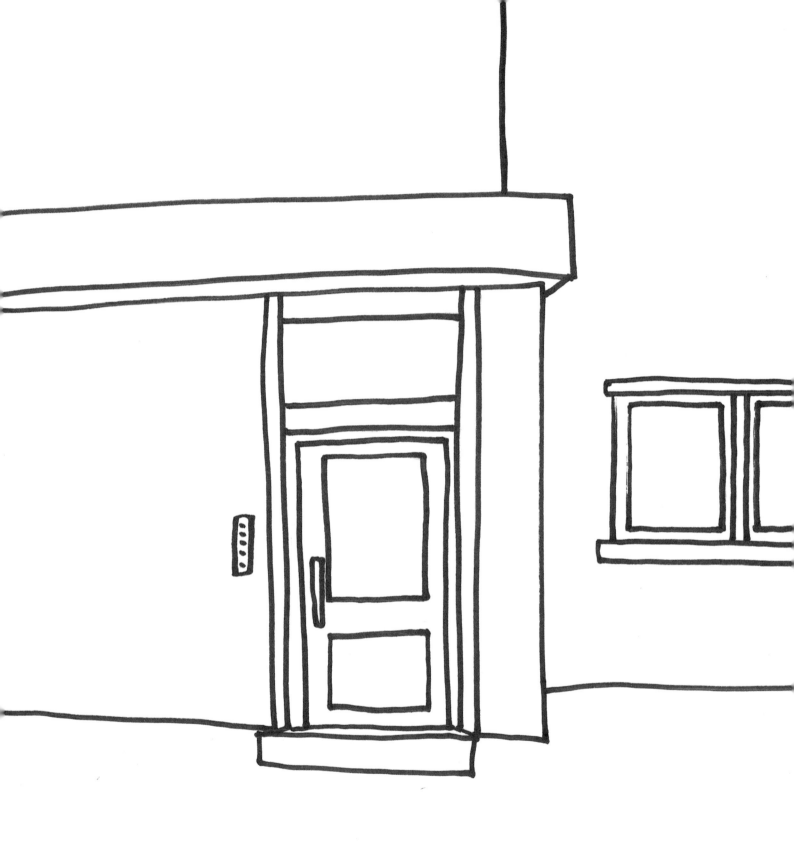

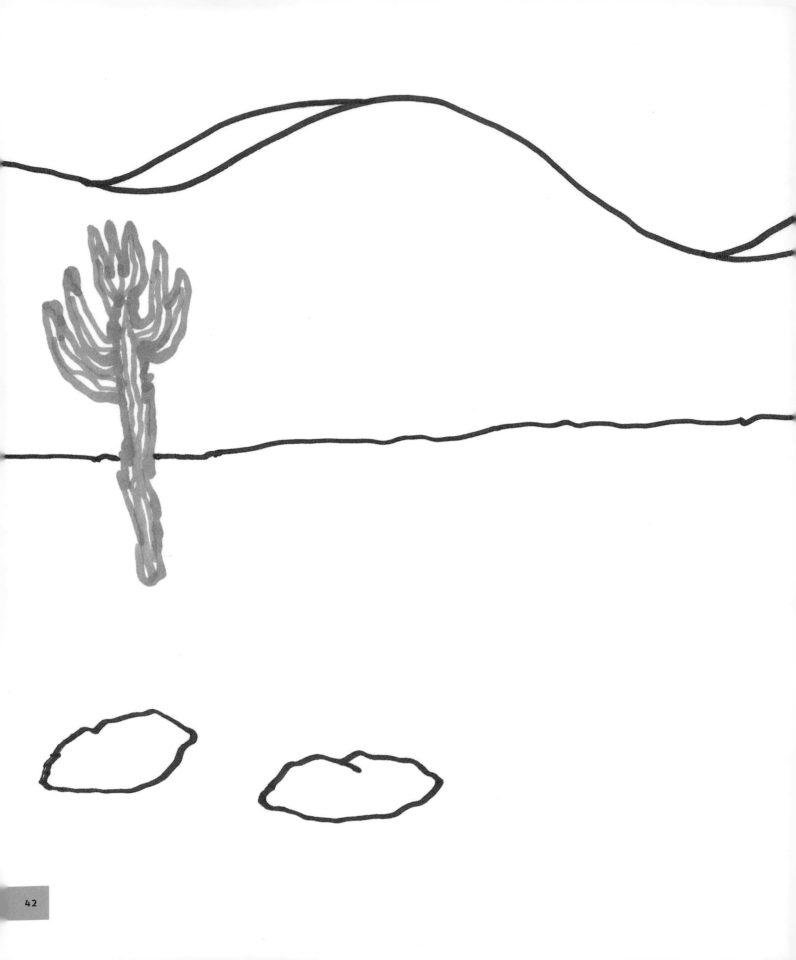

DESERT GARDEN

Dry, hot climates bring gardening pleasures of their own. Cacti and succulents offer an exciting, sculptural flavor to a rocky environment—and why not decorate this wall to complement the planting?

RAIN WATERING

Gardeners have to make the most of every
drop of rain in dry climates. Design a
reservoir to collect water from this downpipe.

RAISED BEDS

Raised beds, which reduce the need for
bending down, are excellent for gardeners
with limited mobility or in wheelchairs. Fill
these beds with flowers and vegetables, and
design your own.

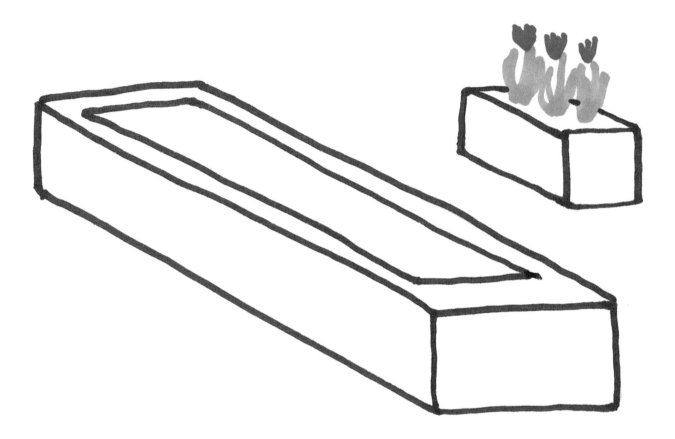

GATE TO GATE

A gate in, and a gate out, but what lies between?

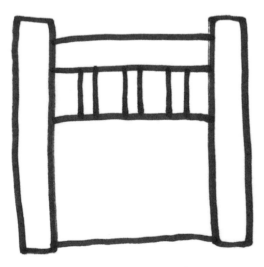

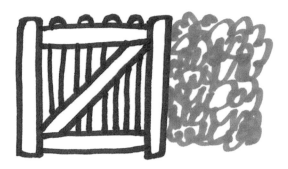

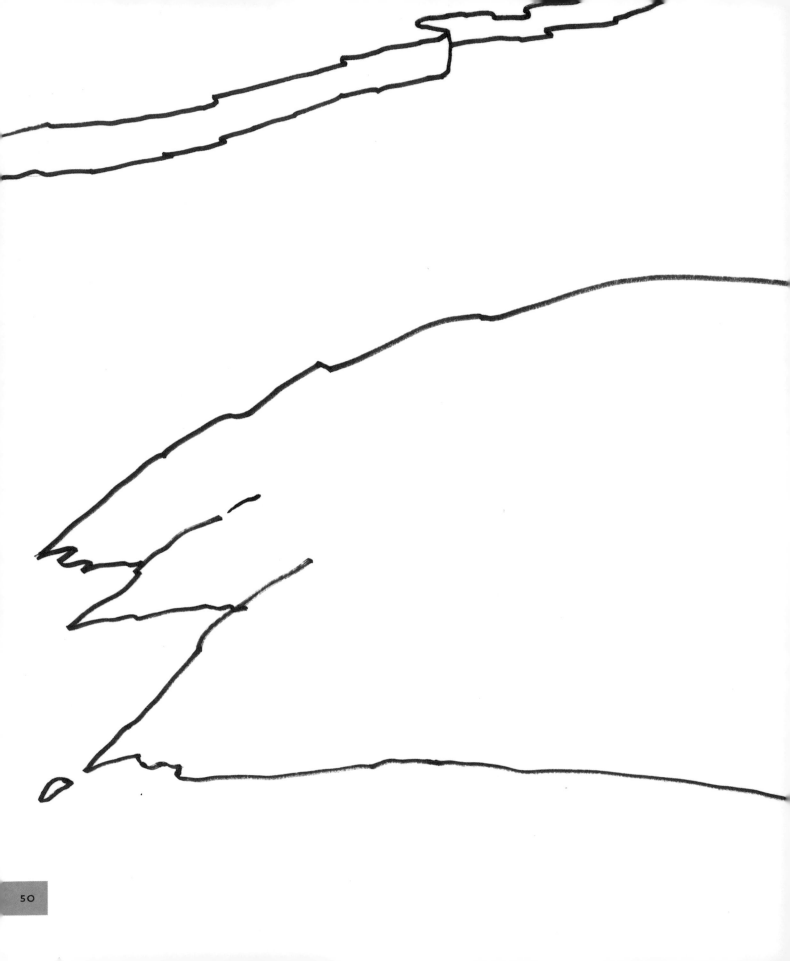

ISLAND

A barren island, close to the coast. Create a verdant getaway with house and gardens.

BOTTOM OF THE STEPS

What's at the bottom of these steps?

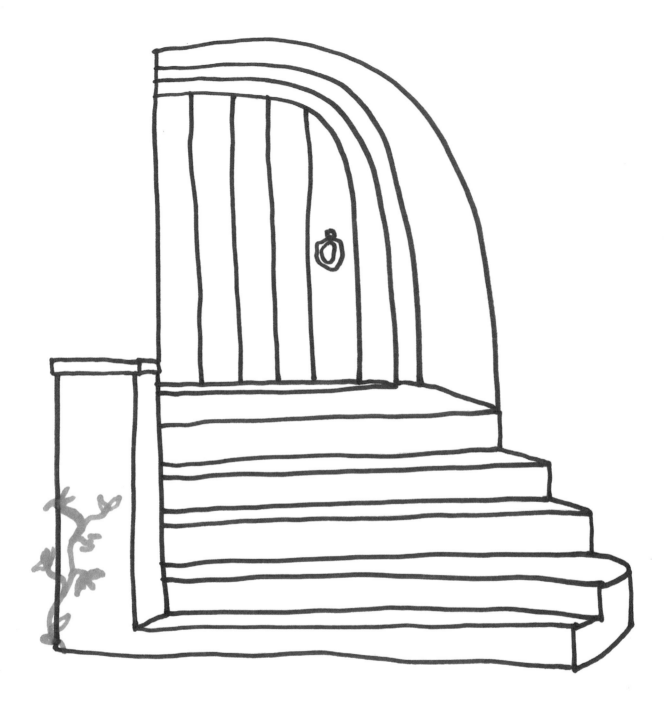

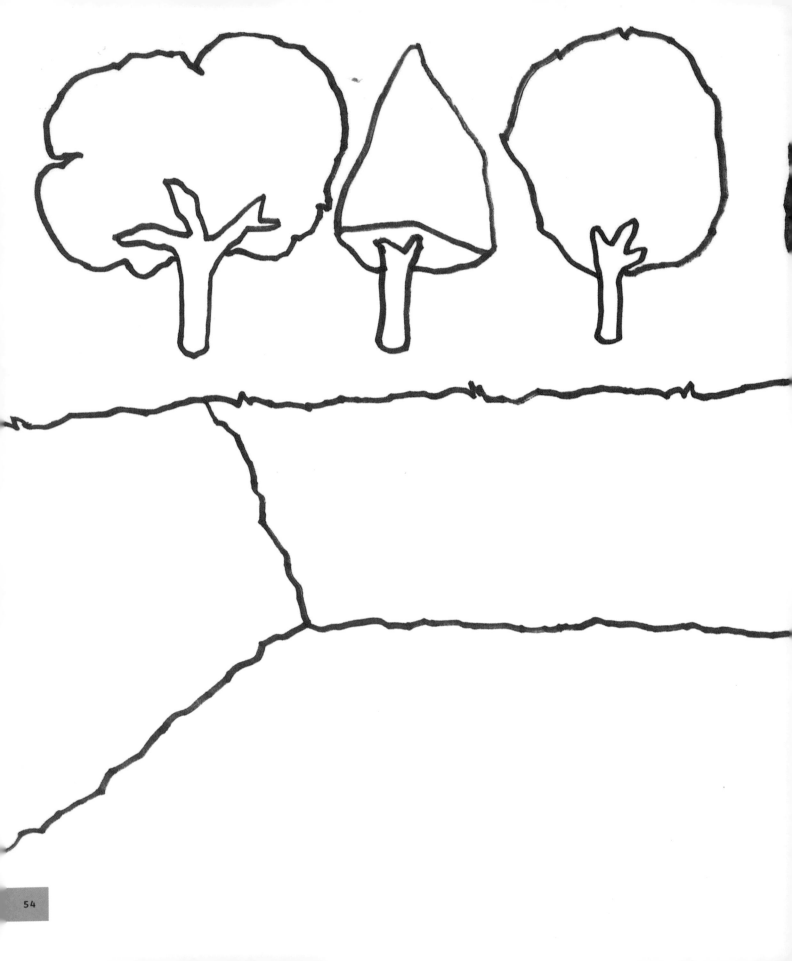

SUNKEN GARDEN

Sunken gardens are often situated in former lakes or ponds, or dug out to create intimate, sheltered spaces that suggest an outdoor room. Design this sunken plot to include a water feature.

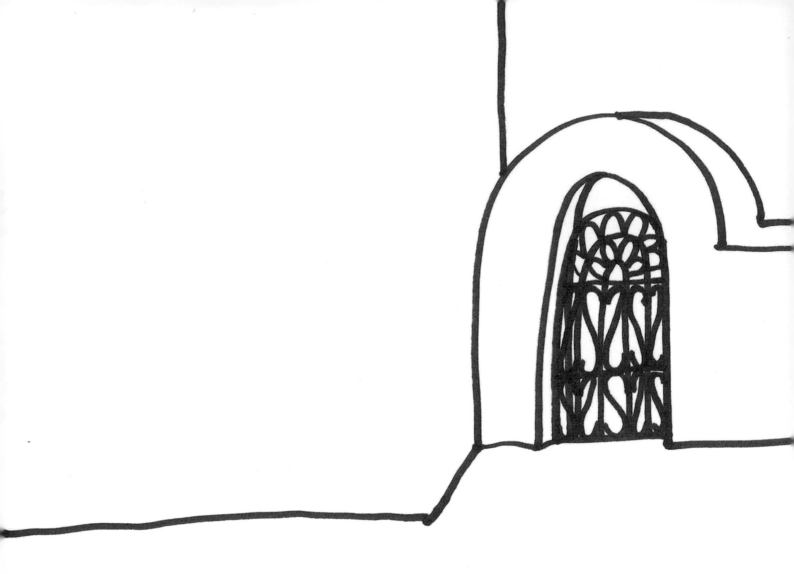

QUIET CORNERS

What do you find as you enter the courtyard through the wrought iron gate?

HANGING BASKETS

Put plants in these hanging baskets—
and design your own.

ROOF GARDEN

Here is a rooftop garden on a city apartment
block, but what does it look like from below?

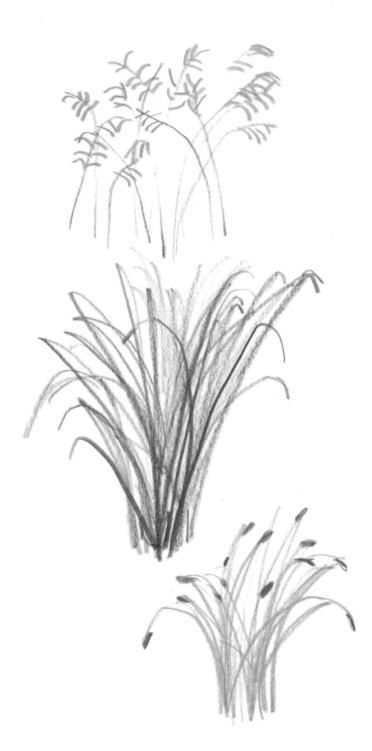

GRASS GARDEN

Grass gardens offer a variety of textures and colors and look great swaying in the wind—and they don't need cutting like conventional lawns do. Draw an expressive swathe of grasses for this garden.

MINIATURE COURTYARD

A small courtyard garden surrounded by walls can have a microclimate of its own, and is ideal for climbing plants, window boxes, containers, and a place to sit close to the house. Prove that small can be beautiful in this space.

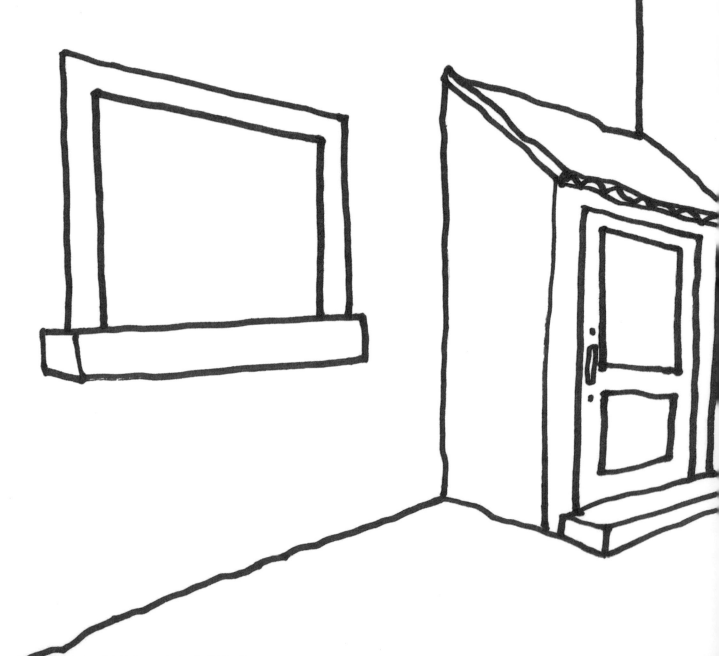

PEDESTALS

A statue? A sculpture? A decorative container
filled with flowers? What goes on this pedestal?
Design some more of your own.

DISPOSAL CAMOUFLAGE

Trash cans and recycling bins can take over a small garden or yard. Create an imaginative and practical way of camouflaging them.

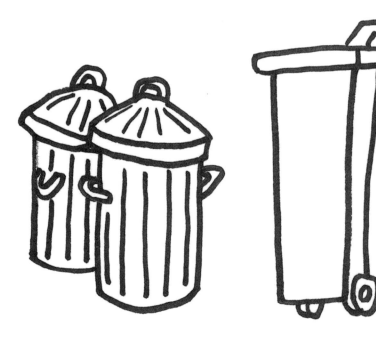

TRELLISES

A trellis is a great way to cover exposed walls or serve as a screen, and can be used with containers. Hide this trellis with climbing plants.

BLANK CANVAS

The earth-movers have been in to clear the
mess of this yard's former keepers, leaving
just two trees—and a blank canvas.

INSIDE AND OUT

The rear glass doors of this city apartment open wide to its small garden. Make the living space flow outside, and create a screen from the overlooking houses.

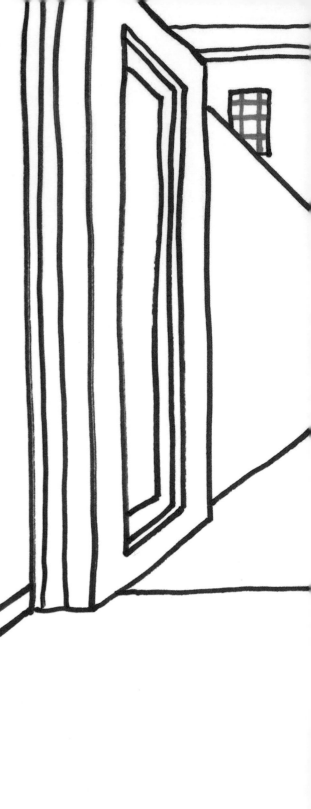

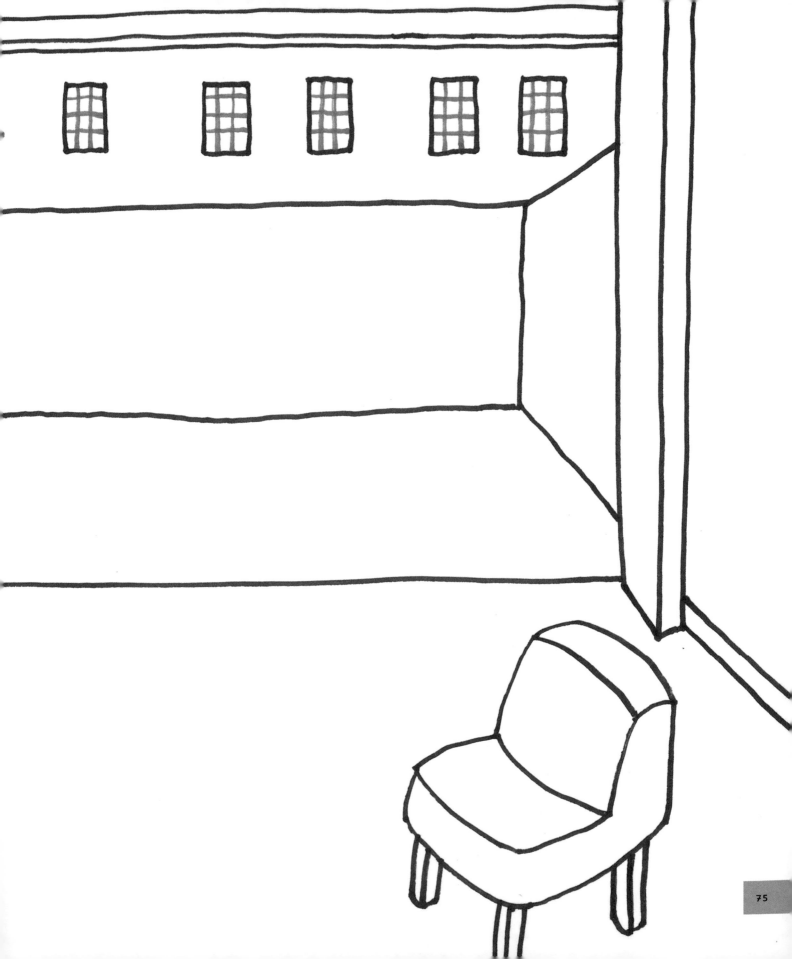

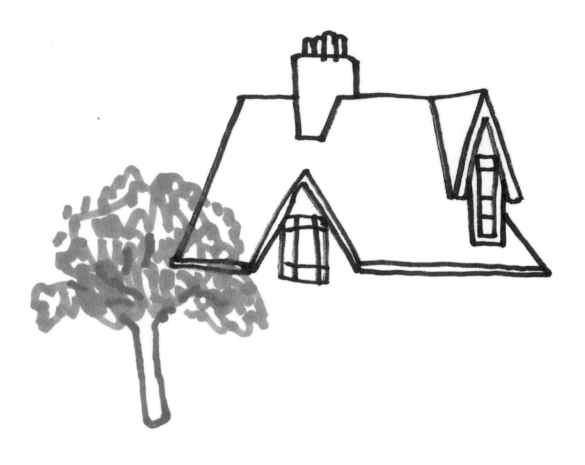

BEHIND THE GATES

A gateway and a rooftop are all you can see
from the road. Draw the rest of the house
and garden.

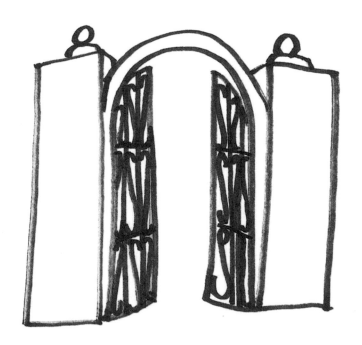

THE GARDEN OF A MODERNIST HOUSE

Design a garden for the straight, Modernist lines of this house.

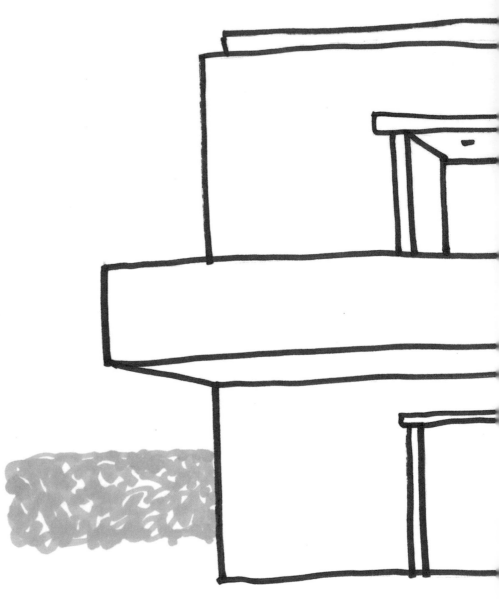

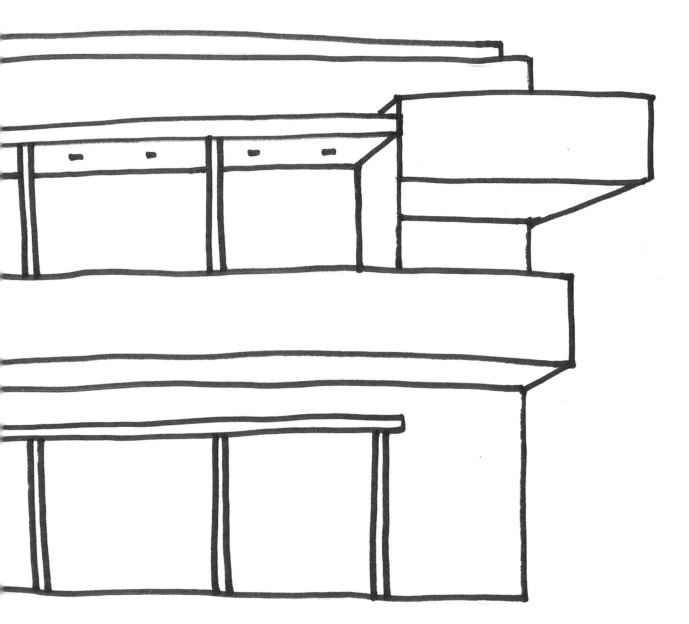

TOP OF THE STEPS

The steps go up, but to what?
House, garden, view?

PERGOLAS

A sunny, secluded spot is ideal for enjoying
the fruits of your gardening labors. Train
climbing plants up this secluded pergola, and
design your own.

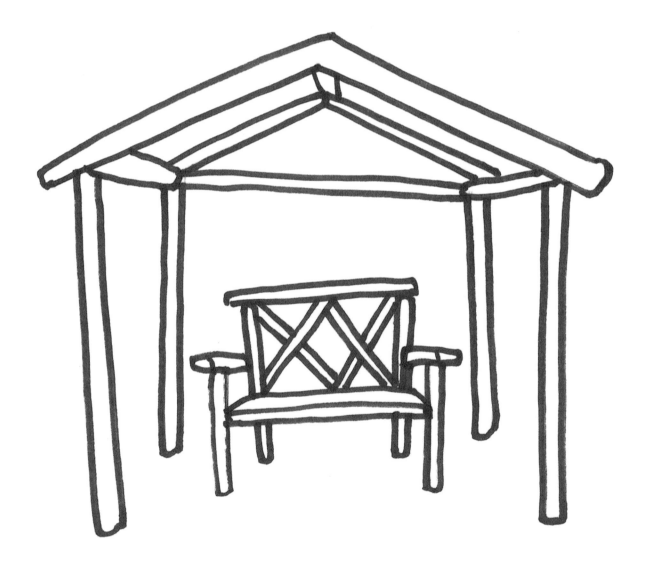

INTERESTING PLANTERS

Plants don't have to be grown in a terracotta pot. Let your imagination run riot with things that can be used as a container.

ENHANCE YOUR SIDEWALK

Around each tree growing along the sidewalk is a small patch of soil. Turn them into a series of mini gardens to brighten your neighborhood.

RIVERSIDE GARDEN

A jetty leads down to the water's edge.
Create a natural, rural garden that needs
minimal maintenance to ensure maximum
relaxation on the riverbank.

TREE HOUSE

A tree house doesn't have to be
only for children. Draw your dream
hideaway in the branches.

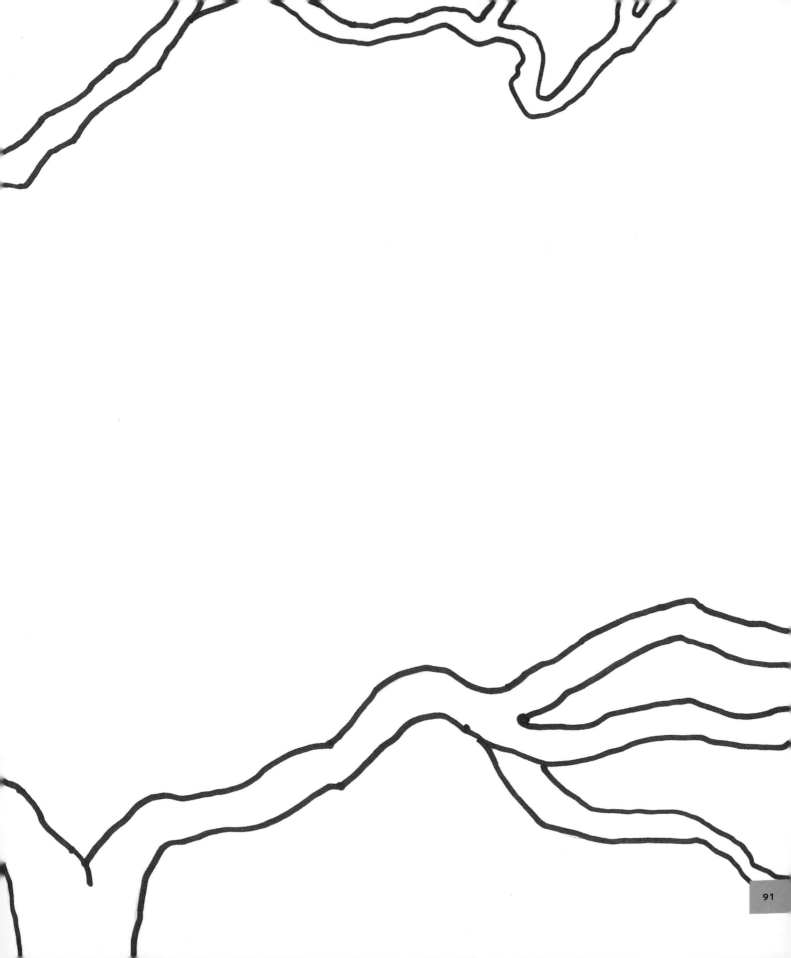

JAPANESE GARDEN

A Japanese garden will often embrace bridges, rocks and sand, ponds, streams or waterfalls, and a reduction in scale to create a natural setting with a calming, spiritual presence. Research to bring out the zen in your drawing.

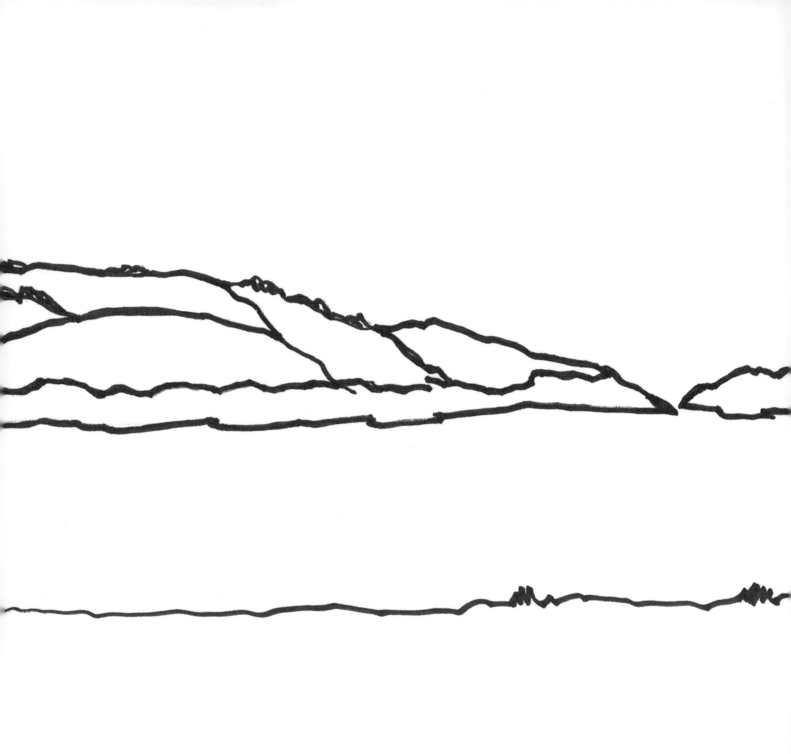

COASTAL VIEW

This south-facing cliff-top garden by the sea
needs shelter from the wind and a place to
relax and make the most of the view.

BALCONY

A balcony, for those without gardens, can be a horticultural blank canvas to stretch the imagination. Bring color and life to the confines of these railings.

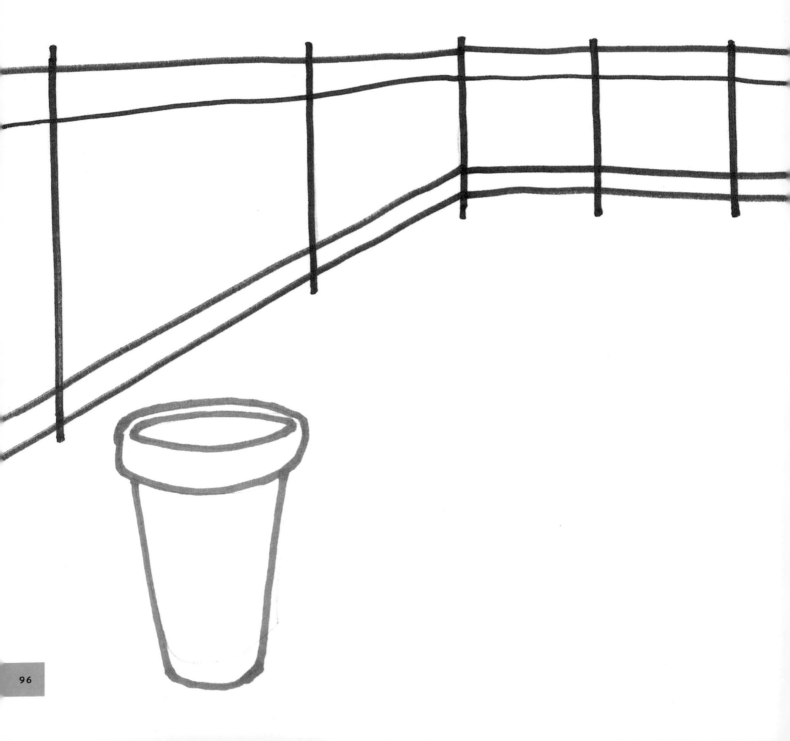

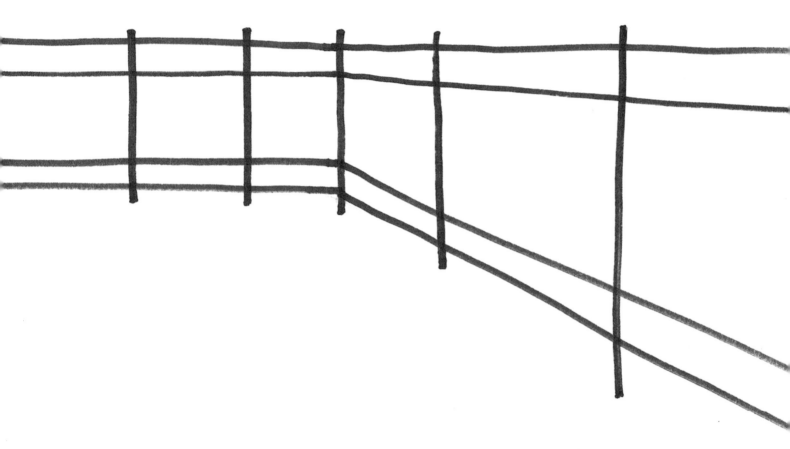

BRIDGE GARDEN

A bridge garden can link two banks of a town
or city to create a beautiful, traffic-free park
with a range of trees, shrubs, and sculptures.
Link these urban banks with a horticultural
pedestrian bridge.

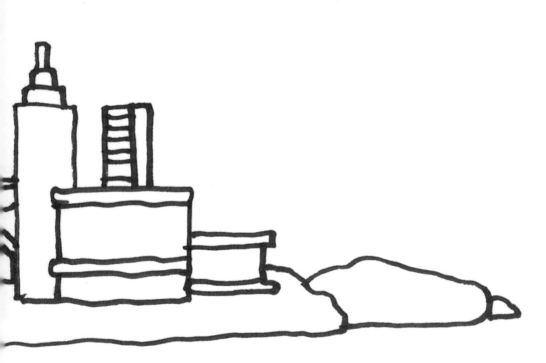

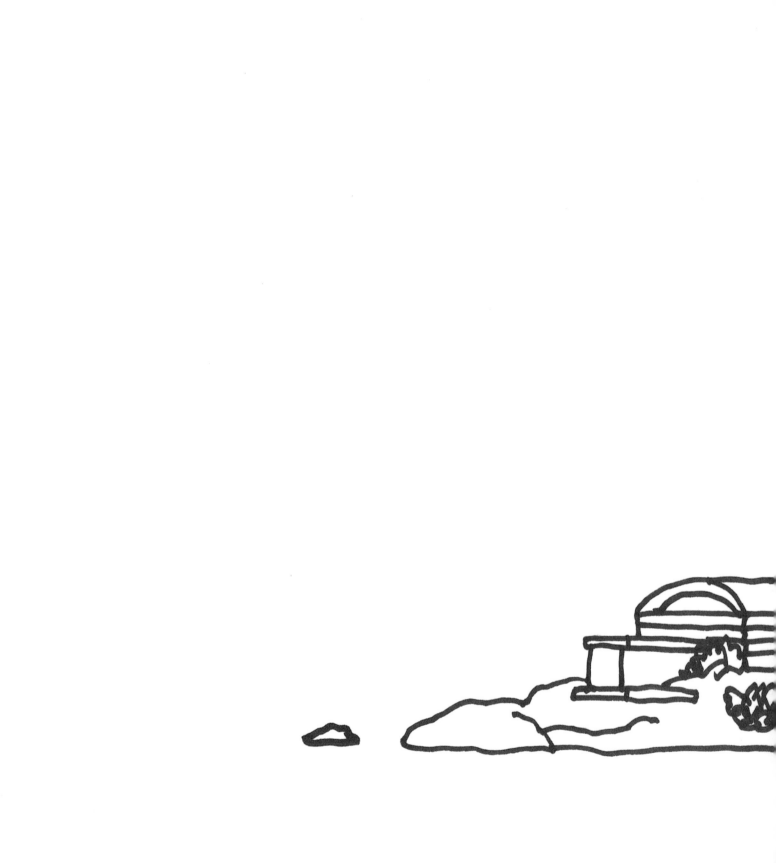

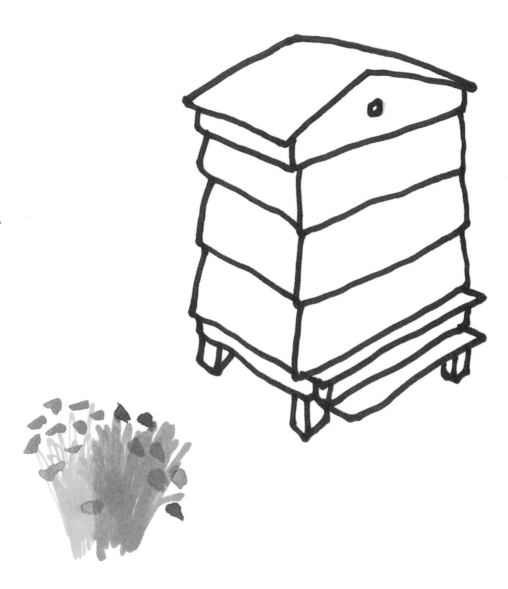

BEEHIVES

Healthy bees are essential for pollination and depend on biodiversity. Create a colorful floral feast for these hives.

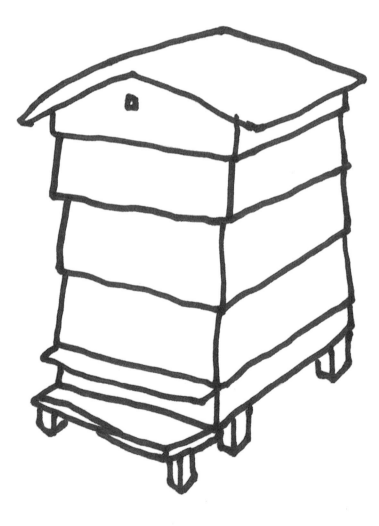

VERANDA

What is better than sitting out on a veranda
on a sunny summer's day? Create a relaxed
botanical vibe to help the laid-back theme.

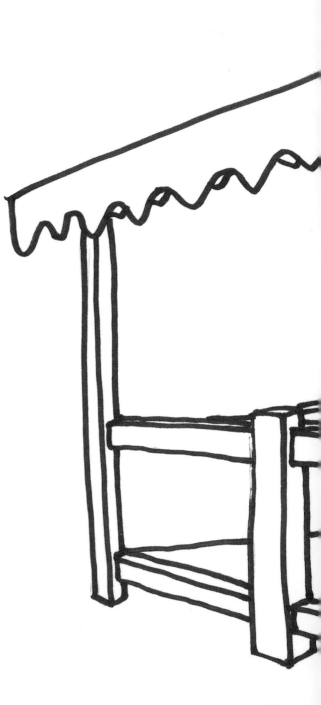

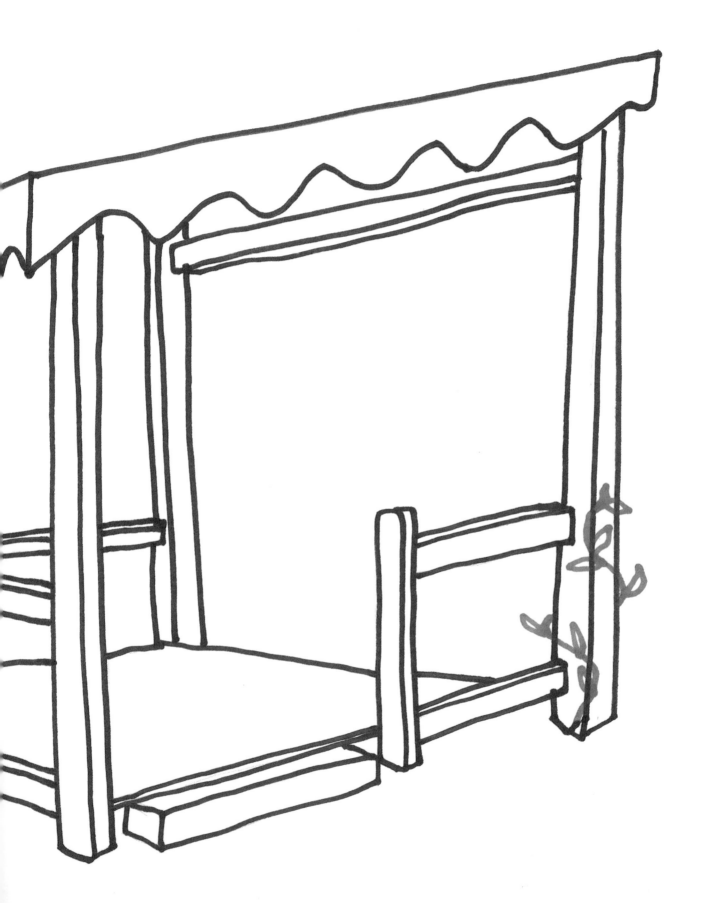

BIRD'S-EYE VIEW

Imagine a garden from above, from a roof terrace or high window. Incorporate these trees into your panorama, and lay out its design with flower beds, lawns, footpaths, a vegetable garden, and whatever else you would like to see.

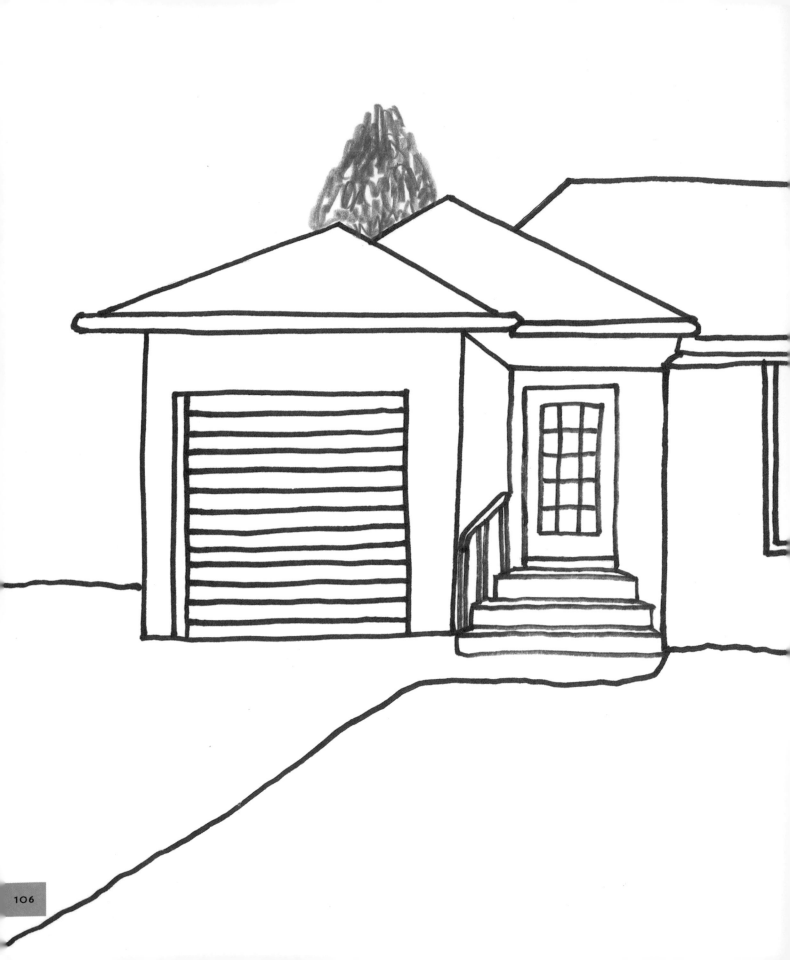

THE GARDEN OF A SUBURBAN HOUSE

Design a garden for this house.

COLORED COURTYARD

This small, enclosed yard needs color. Brighten its walls with paint and tiles, and plant colorful containers with shrubs and flowers. Design a gate or door, or draw the view through it.

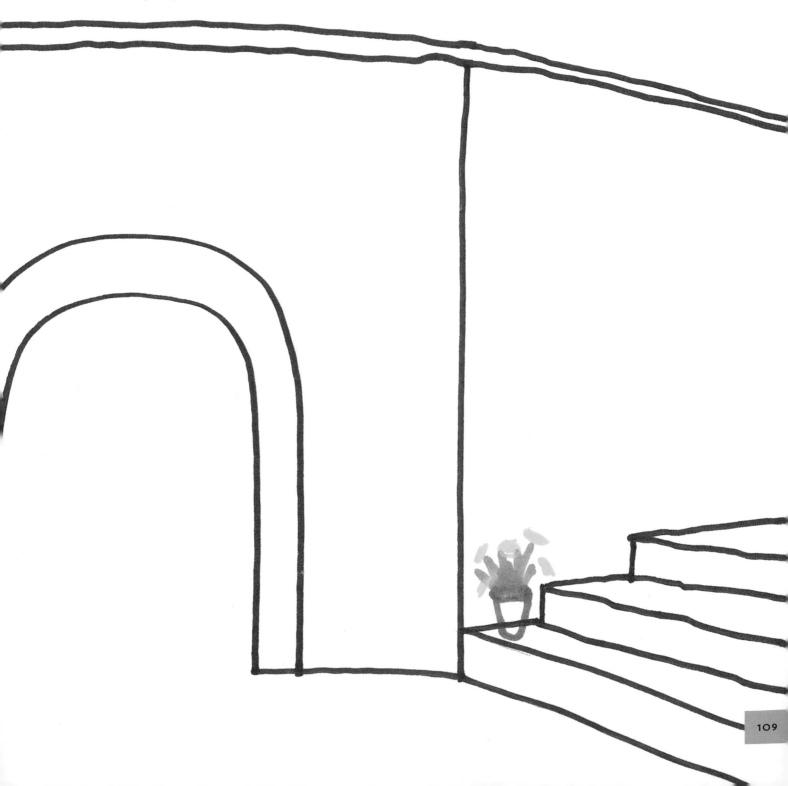

STEPPING STONE PATH

Swamp this stepping stone path with plants so you have to push your way through on a tactile journey into the undergrowth.

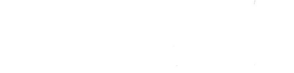

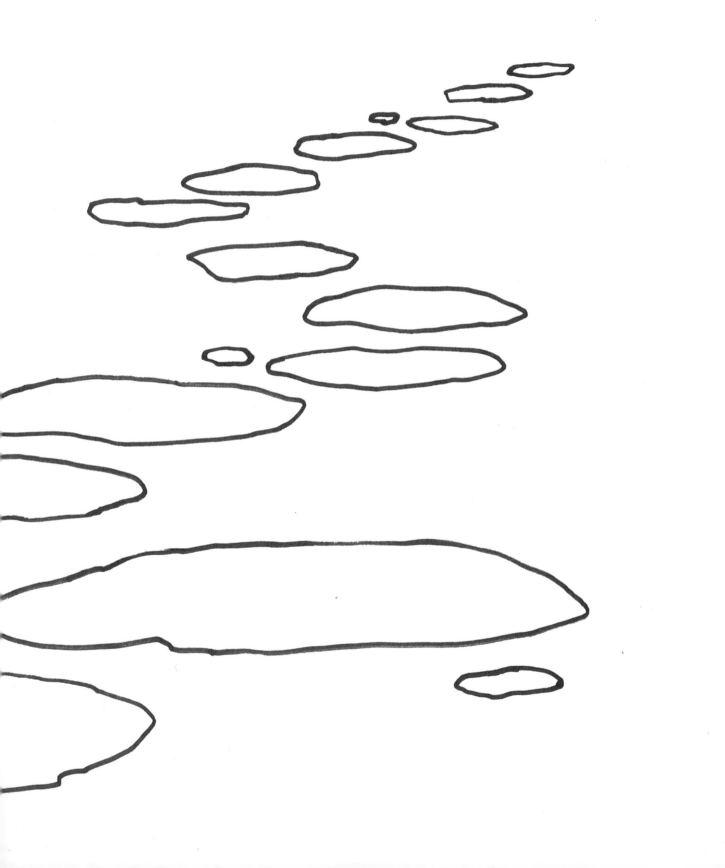

GREENHOUSES

Greenhouses can help control the
temperature, humidity, light, and
shade to the best advantage of their
plants—and provide a warm shelter
for the gardener on cooler days.
Fruit, flowers, vegetables?
You decide.

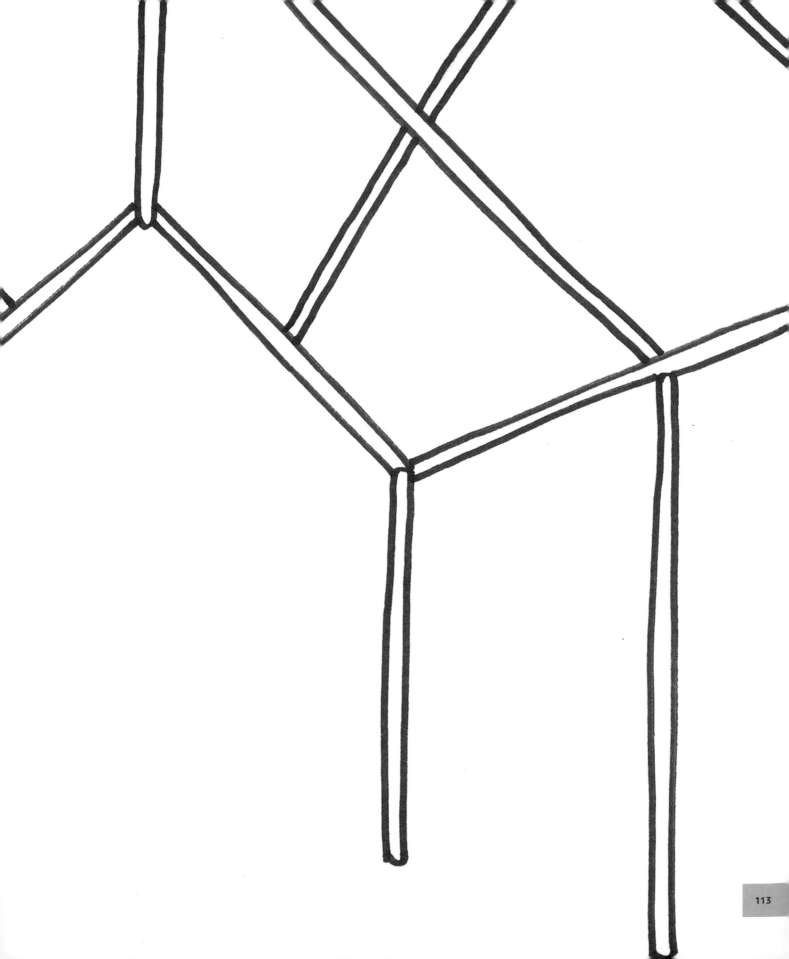

BEACH PATH

Imagine your garden running down to the beach,
in a place where the sun shines each day. Design
a relaxed and shady environment, perhaps with
driftwood and found materials, and a seating area
to soak it all in.

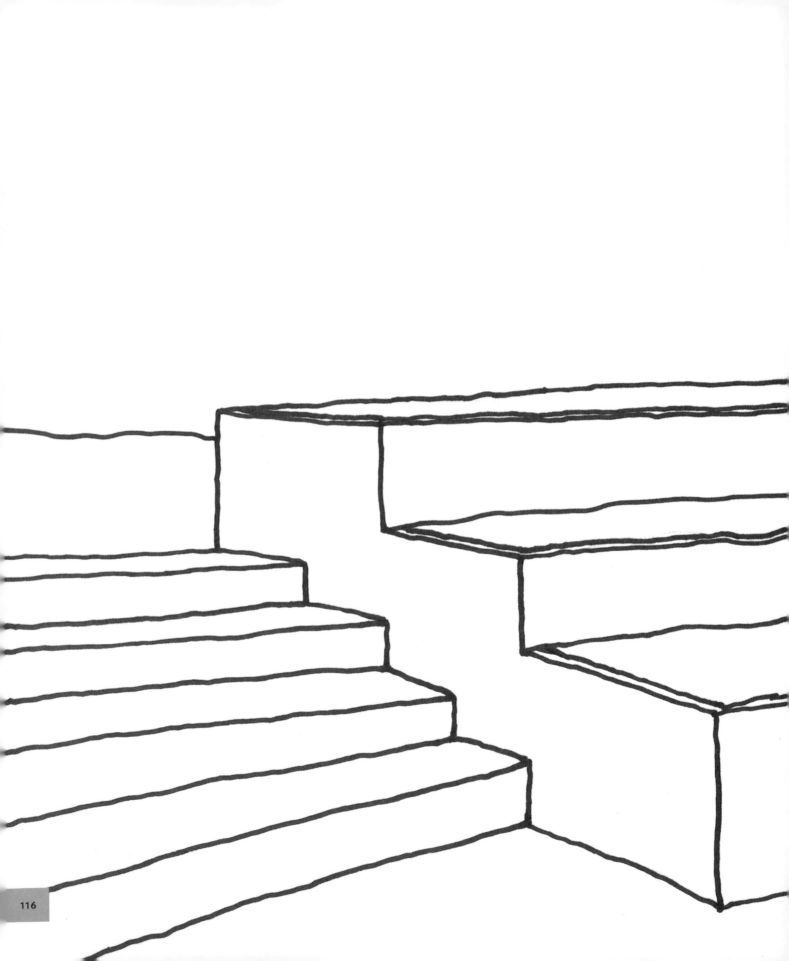

STEPPED BEDS

These terraced beds alongside steps are
a way of linking the two levels of a sloping
garden. Create a tumbling, waterfall effect of
plants and shrubs.

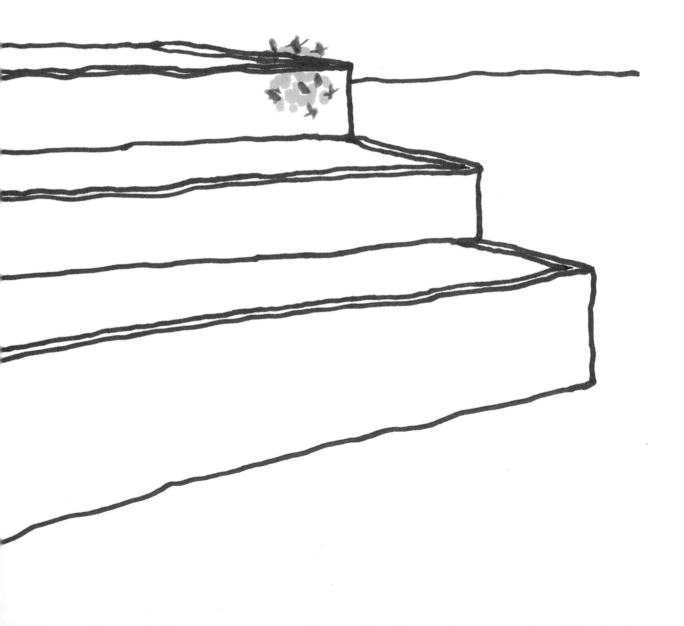

SECRET SHED

Who doesn't like the idea of a shed to escape
to at the bottom of the garden? Design and
furnish your hideaway.

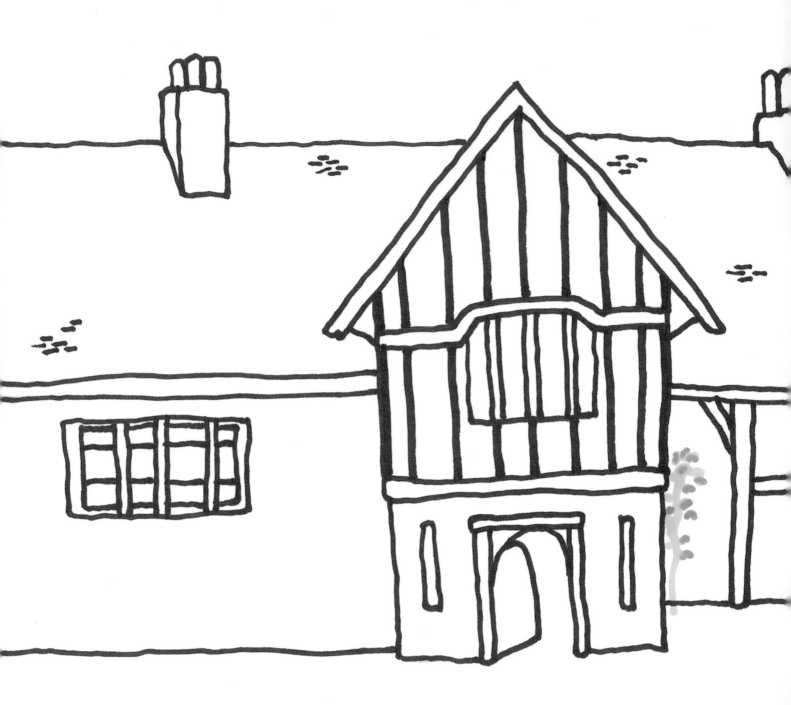

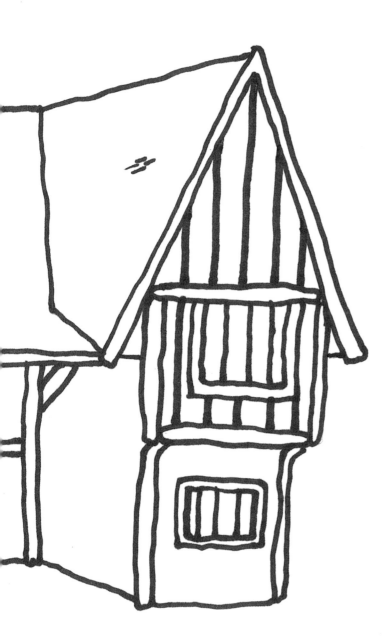

THE GARDEN OF A TUDOR HOUSE

Pretend you have a big house like the one here and design its garden.

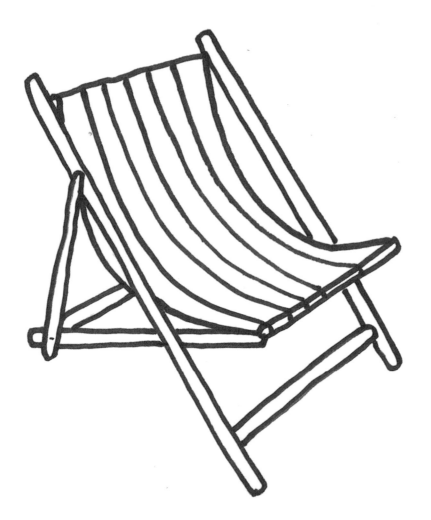

SHADE TO SIT

Deck chairs are waiting for you to slip into
on a humid summer's day. Paint their stripes,
and create a shady setting to relax in.

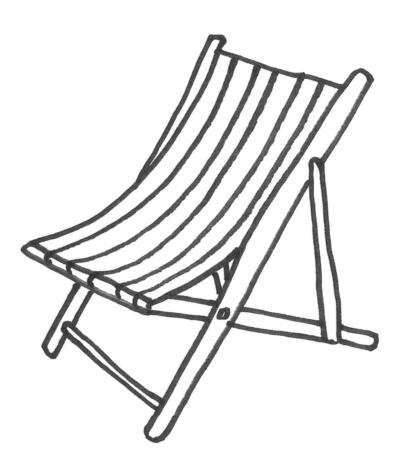

STAIRWAY TO STYLE

Here is the first step of a stairway, but what form will it take? Think of handrails, paving design, and color. How many steps? And what are they leading from and to? Design your own steps.

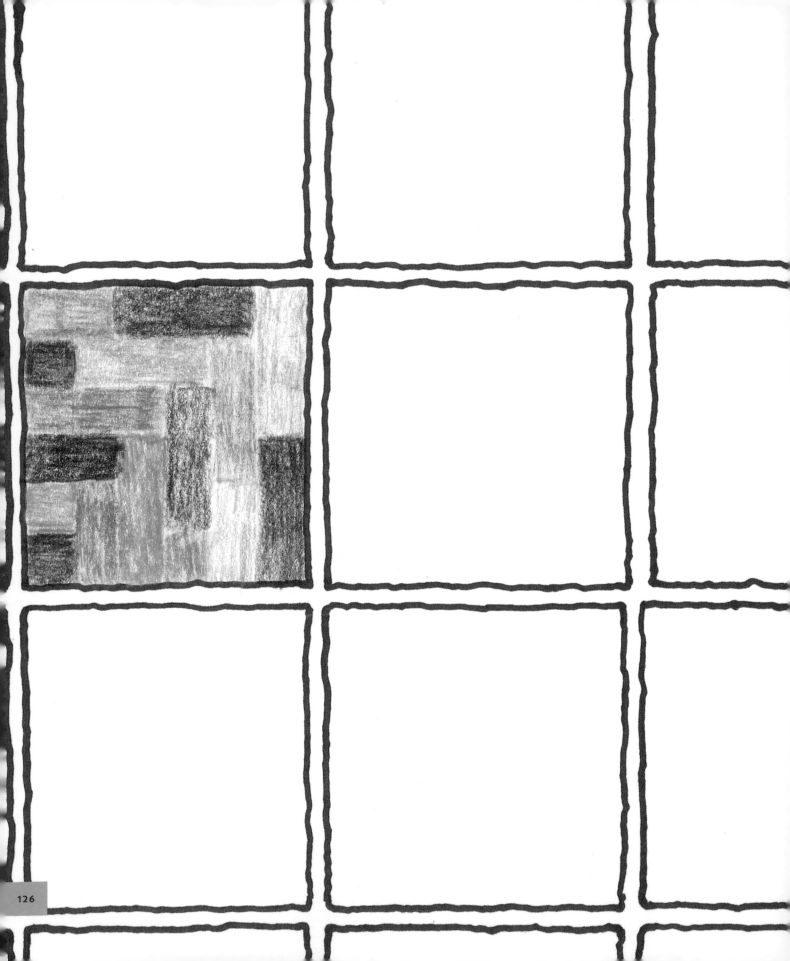

PAVING STONES

When a backyard is fully paved, you don't have to replace all the pavers to create a fresh look. Instead, use bricks, colored tiles, mosaic, and recycled fragments to take the place of some of these slabs, and plant aromatic plants between them.

RECLAIMED STREETSCAPE

A small flower bed on the sidewalk, a forgotten corner of a local park, a patch of bare earth by the bus stop—brighten your day and that of many others by sowing a touch of color through guerrilla gardening.

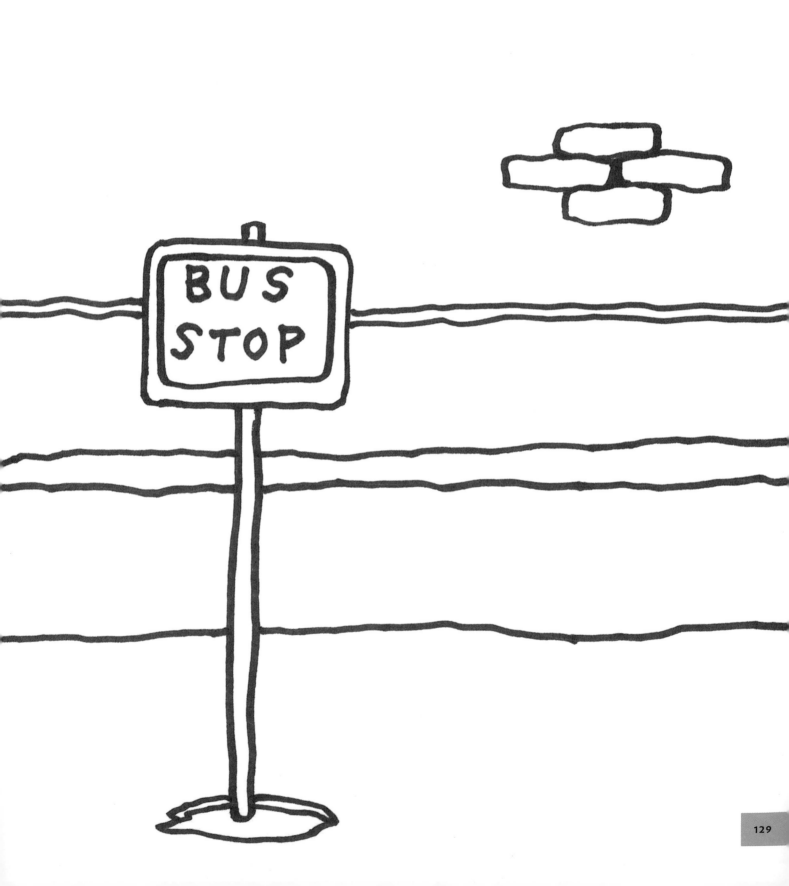

ORCHARD

Planting an orchard of fruit trees takes time and careful planning. Let your dream start here by drawing a sheltered, south-facing slope for apple, pear, plum, and cherry trees.

AGAINST THE WALL

Fruit trees trained to grow along a wall,
known as espaliers, save space and are
attractive whether in fruit or not. Draw apple
and pear trees laden with fruit across this
garden wall.

BUG HOTEL

Encouraging insects into a garden can help to
control pests. Build a bug hotel from objects
such as dead wood, dry leaves, bark, pine
cones, hay, and recycled objects such as
bricks and timber with holes drilled into it,
and top it with a sloping roof. On the opposite
page, design your own.

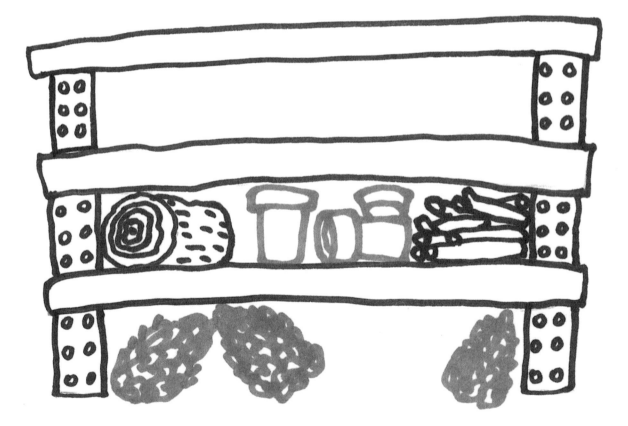

HERB GARDEN

Herbs are easy to grow all year round. A few containers or raised beds by the kitchen door make them easy to pick and use, as well as an attractive and aromatic display. Fill this space with herbs and label them.

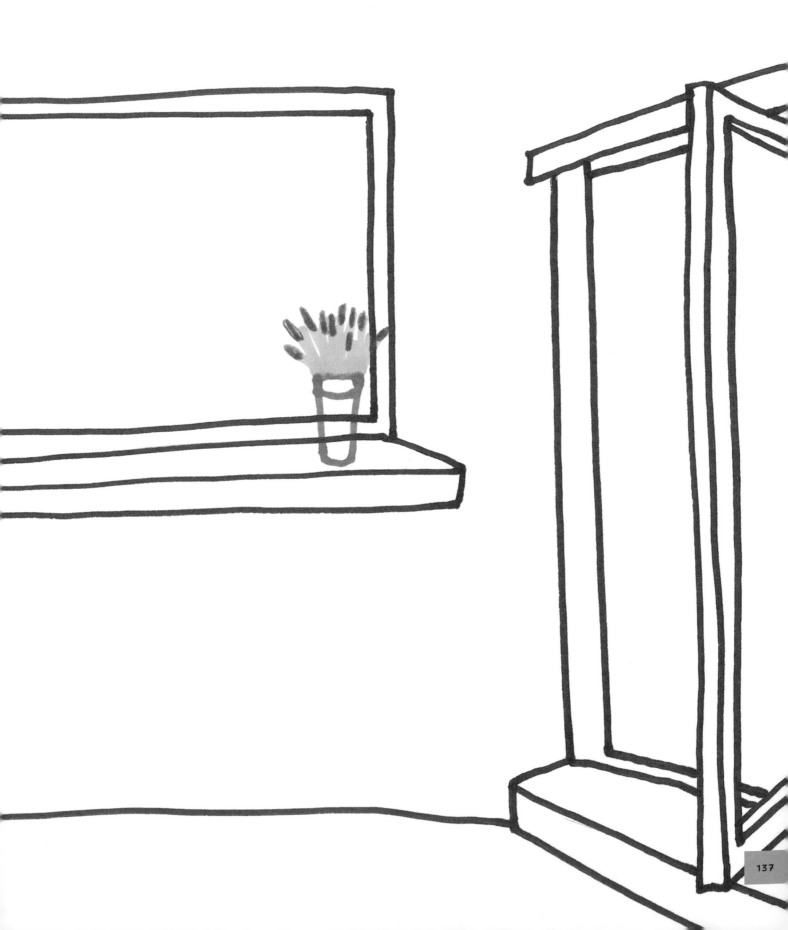

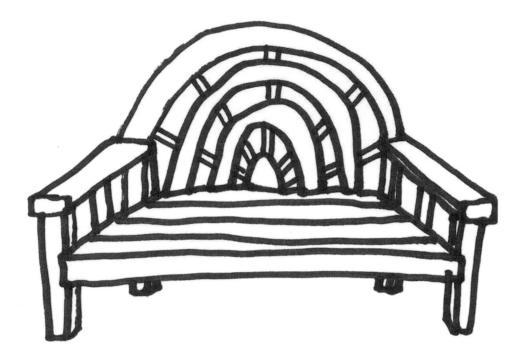

DESIGN A BENCH

How better to enjoy your garden than to
sit and take it all in on a bench you have
designed in the shade of a tree? Design
your own.

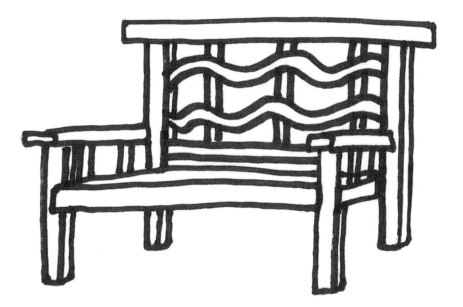

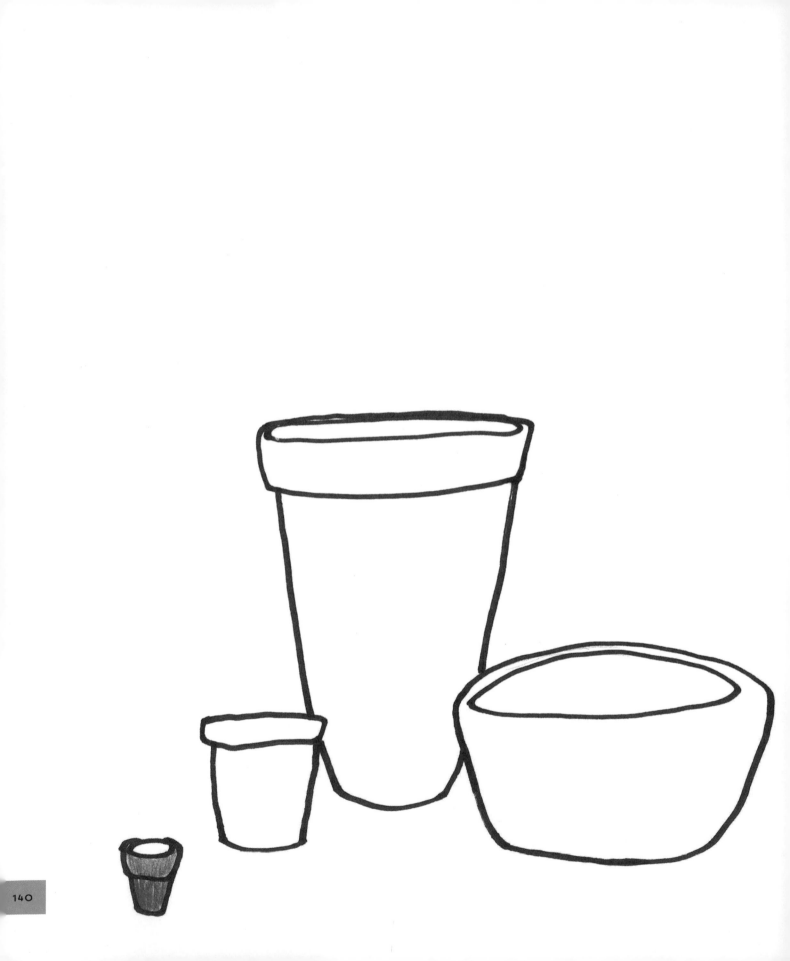

CONTAINER GARDEN

When a space isn't suitable for planting directly in soil, such as when it is completely paved, containers take over. Fill these containers and add more.

VIEW OVER ROOFTOPS

You awake in a new house, pull the curtains,
throw open the window, and look through the
sunlit rooftops to a garden. Draw it.

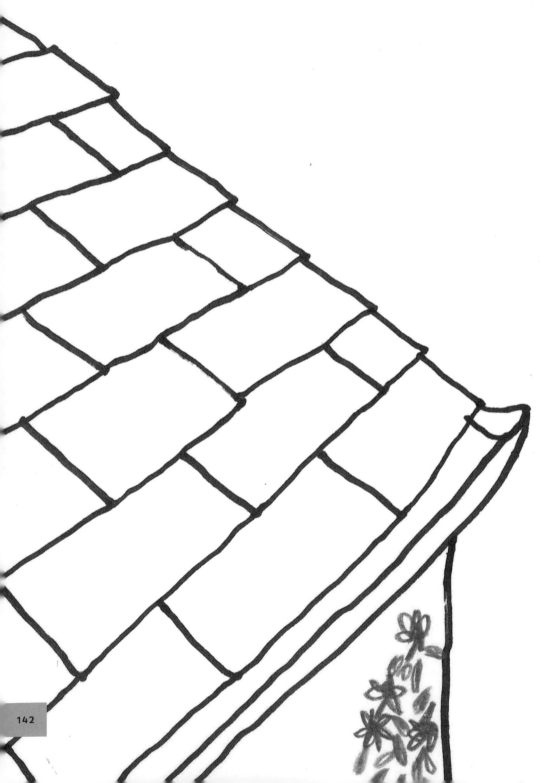

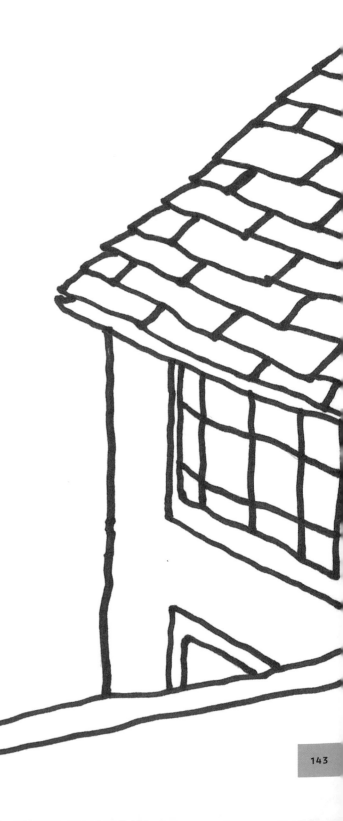

OPEN FIRE

Why should the garden be off limits in
the cooler months? Create a cozy seating
arrangement and lanterns around this metal
fire-bowl as the sun goes down, and on the
opposite page, design your own fire pit and
its setting.

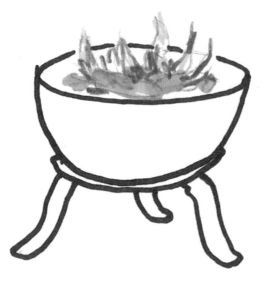

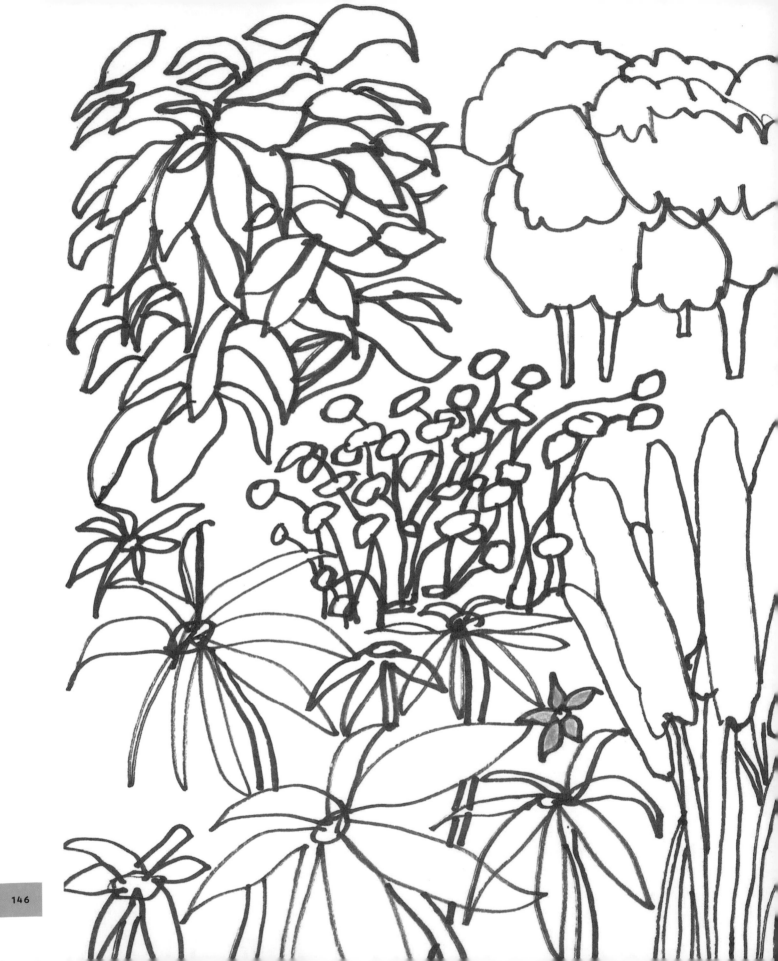

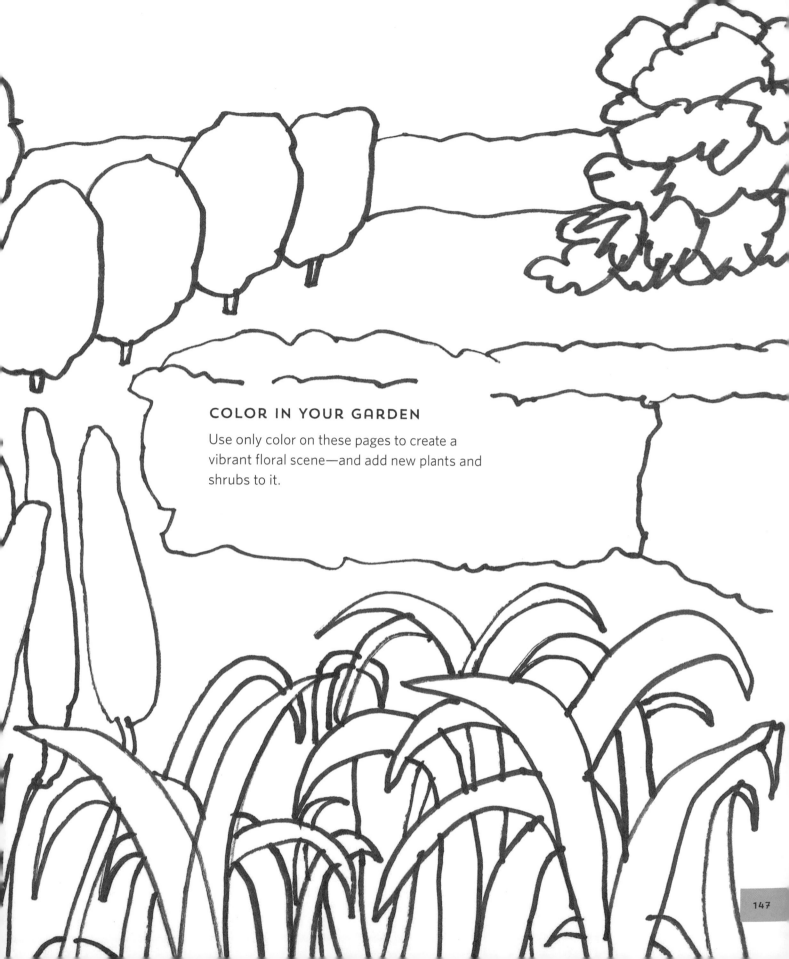

COLOR IN YOUR GARDEN

Use only color on these pages to create a
vibrant floral scene—and add new plants and
shrubs to it.

BOTTOM OF THE YARD

What do you find at the bottom of your yard? A compost heap? A shed? A log store? Somewhere to secure your bikes? A chicken house? A swing hanging from the branches of a tree?

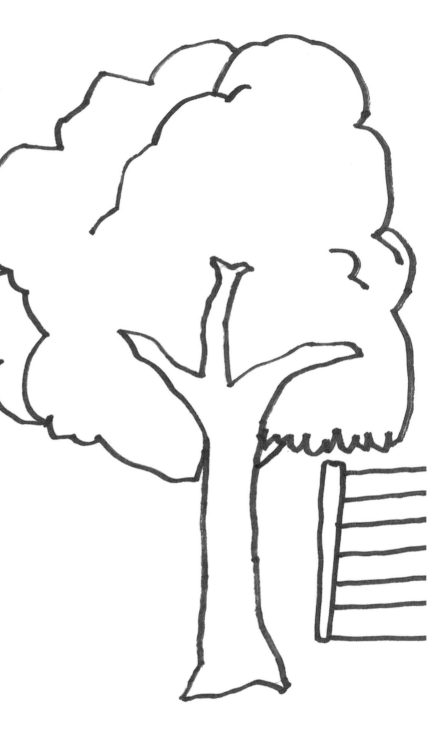

DESIGN A FENCE

The right kind of fence for your garden will depend upon the setting and its purpose. Experiment with different fence posts and materials to create a backdrop for your planting, and think of using color to display flowers and shrubs at their best.

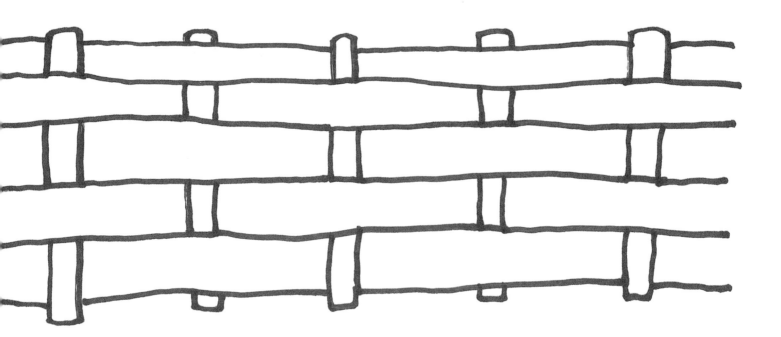

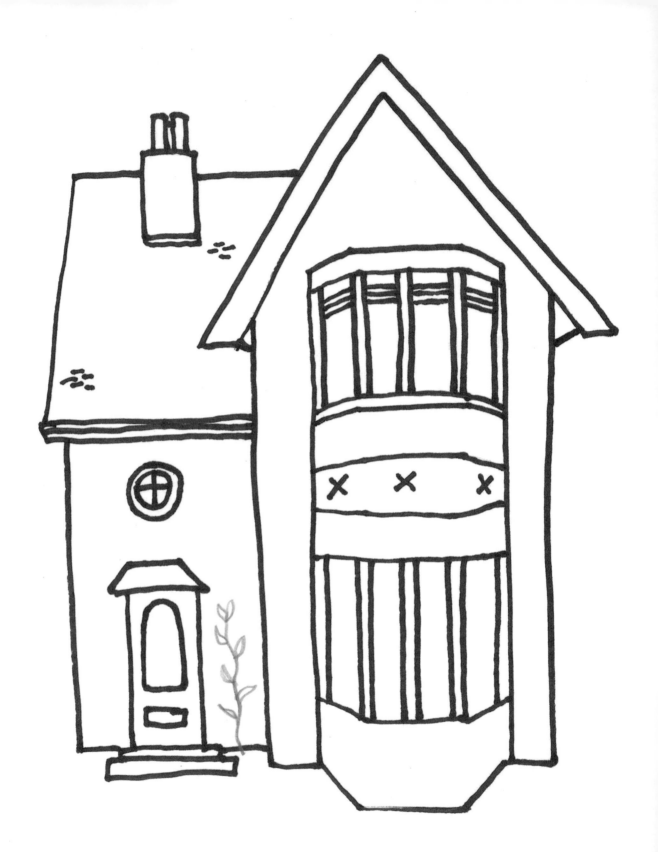

THE GARDEN OF A 1930'S HOUSE

Front yards are often dominated by parking spaces and trash cans. Create an exotic and colorful display—and perhaps a vegetable patch—to bring this house to life.

BARBECUE AREA

Create your ideal barbecue area beneath this arbor. Consider the cooking area, a place to sit and eat, climbing plants, and the paving stone design.

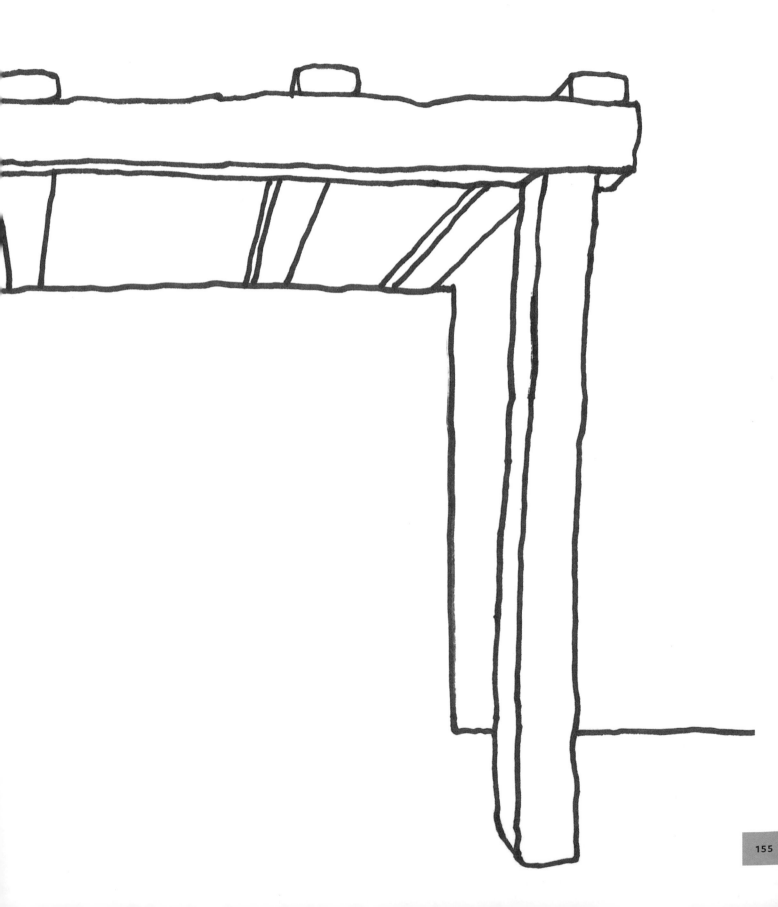

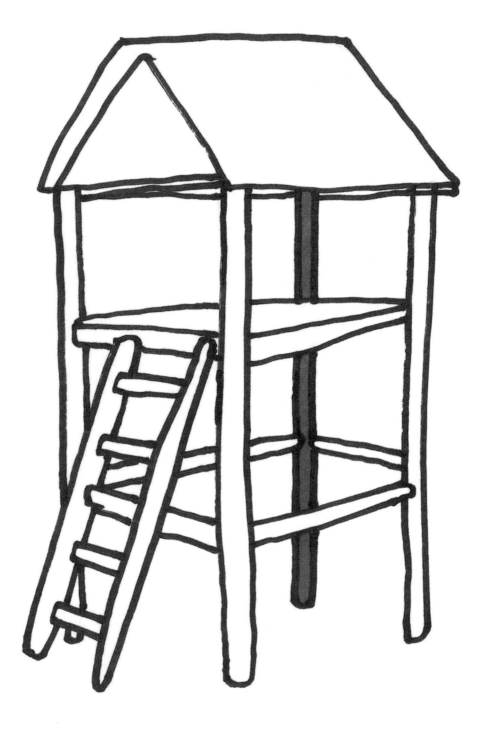

PLAY AREA

A corner devoted to a swing, climbing frame, and seesaw will be popular with younger children or grandchildren. What about a tree to climb in? Think of safety and soft landings as well as fun.

TWO GARDENS

These neighbors have mirror image gardens.
Plant them in contrasting styles, paint the
fence, design the gates, and make them
stand out.

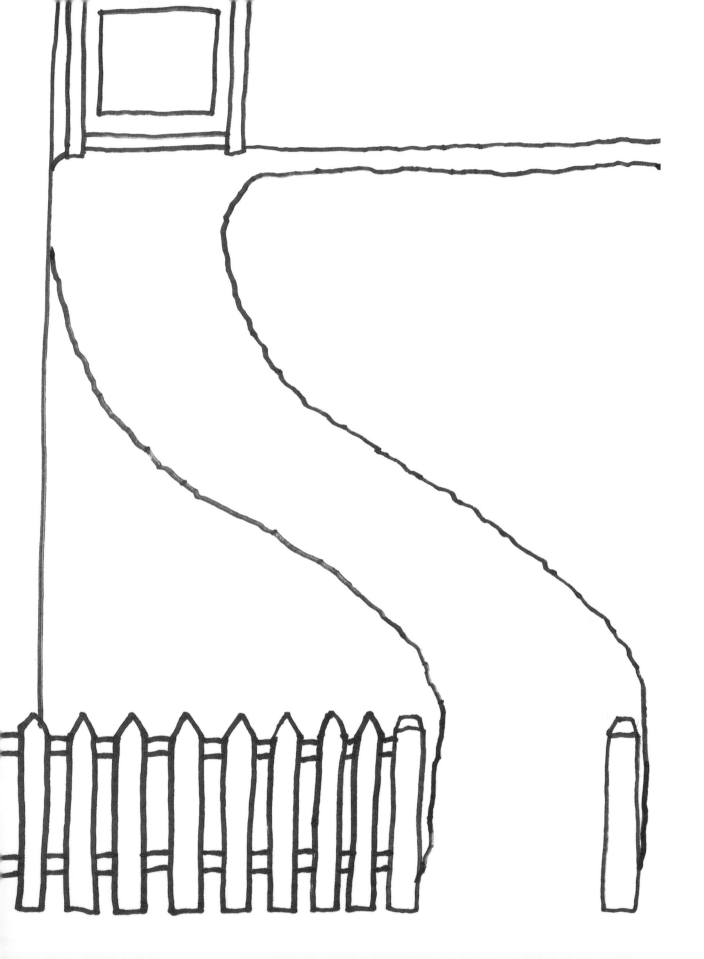

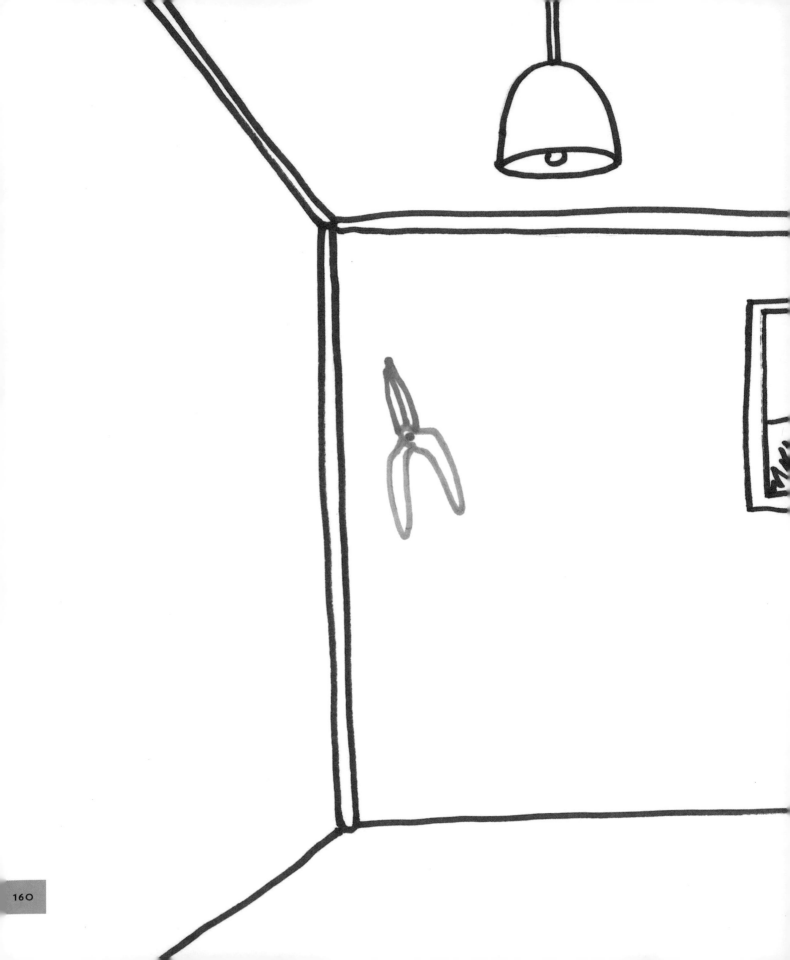

ARRANGE YOUR POTTING SHED

Arrange your tools in the shed—spades, forks, rakes, flowerpots, lawn mower, and other equipment. Create a horticultural home at the bottom of your yard.

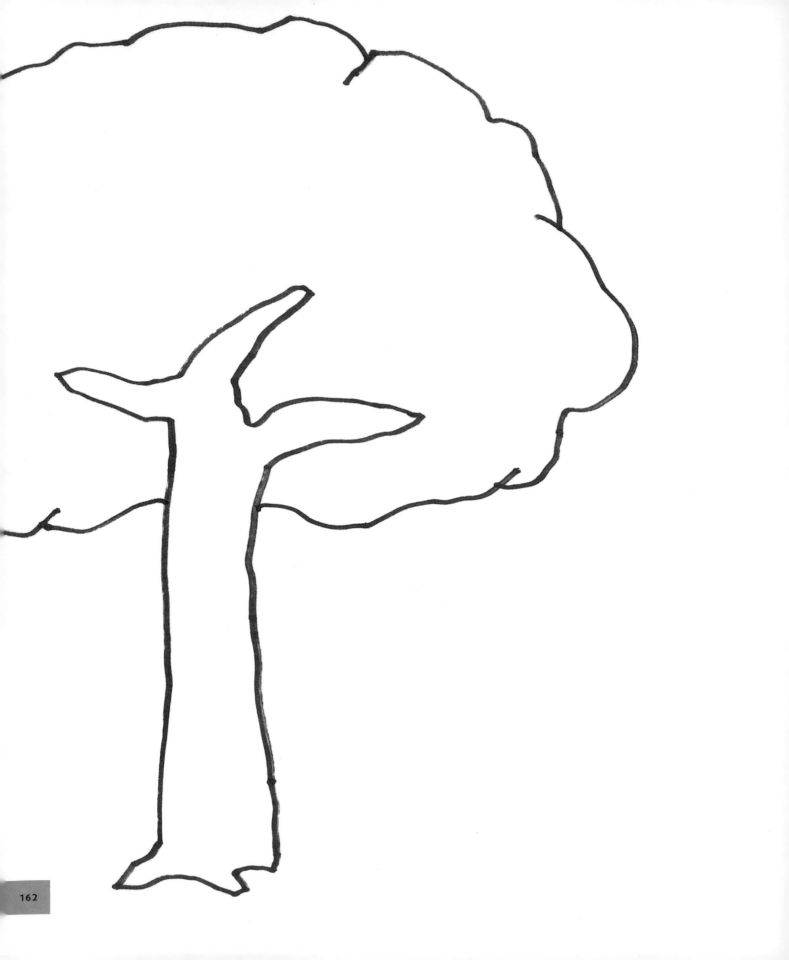

ATTRACT WILDLIFE

A garden can be a magnet for wildlife. Birds
can benefit a garden as pest controllers,
as well as through their song and color.
Welcome them with feeders, bird tables, and
a water supply, and attract insects and other
wildlife with diverse plantings.

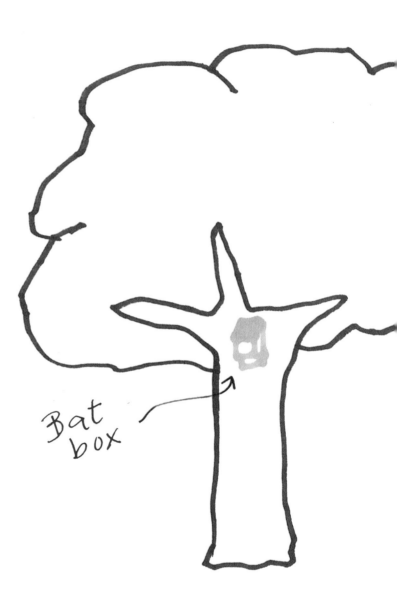

Bat
box

DESIGN A GATE

What kind of gate will fit these humble
gateposts? Design your own. Opposite,
draw the surroundings of this elaborate,
wrought iron gate.

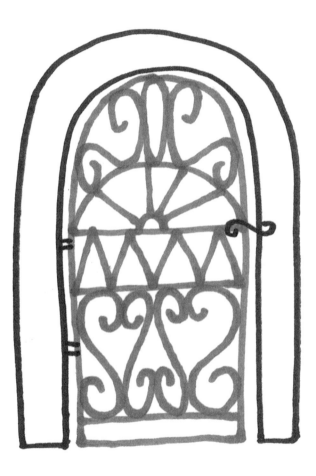

IN THE SUNROOM

A sunroom can be the step between the garden and the house, where the plants and sunlight flow from outside into a living space in which to relax. Turn this sunroom into a green haven with furniture and a glimpse of the garden beyond.

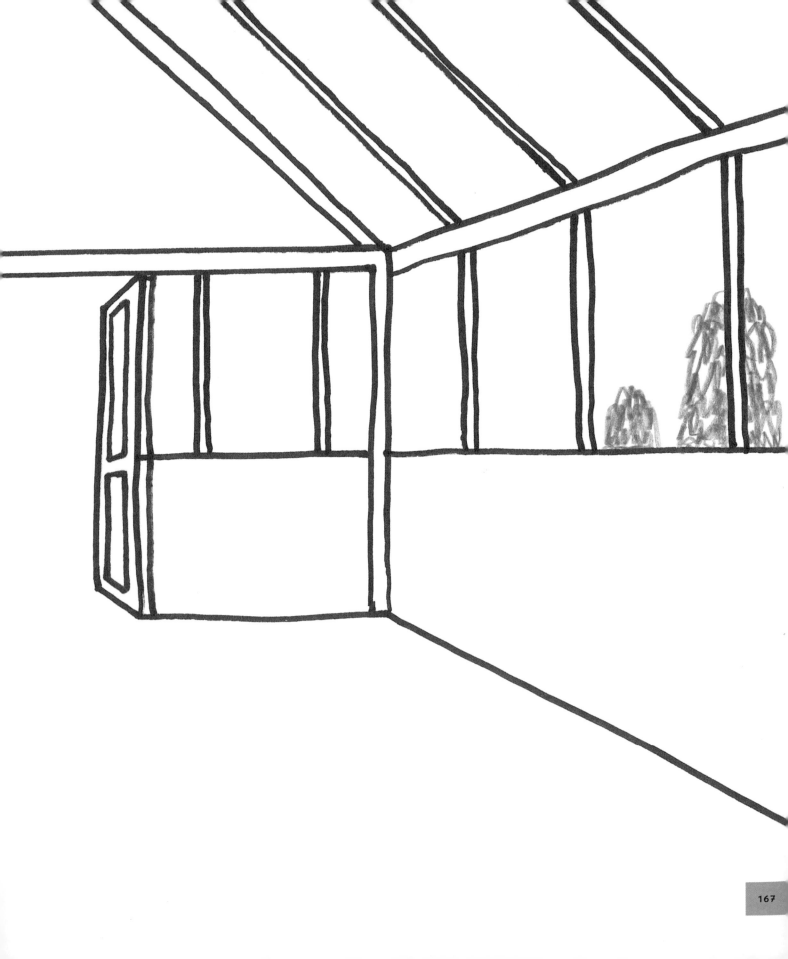

APARTMENT BALCONIES

What would your apartment block look like if all its inhabitants had green fingers? Liven up these balconies and the communal front garden.

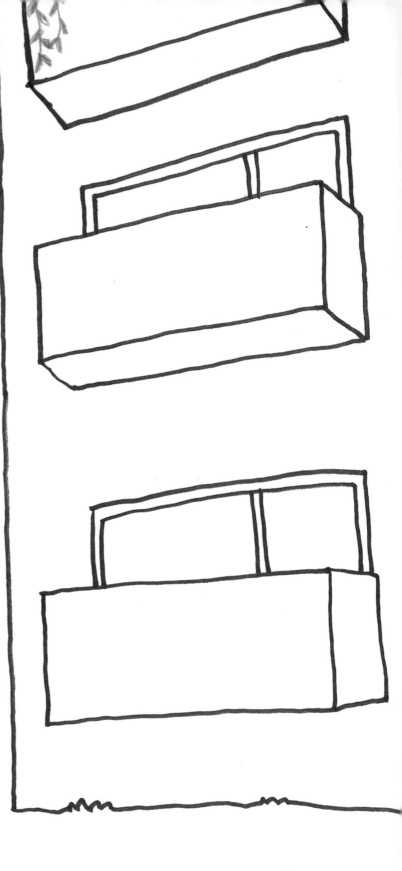

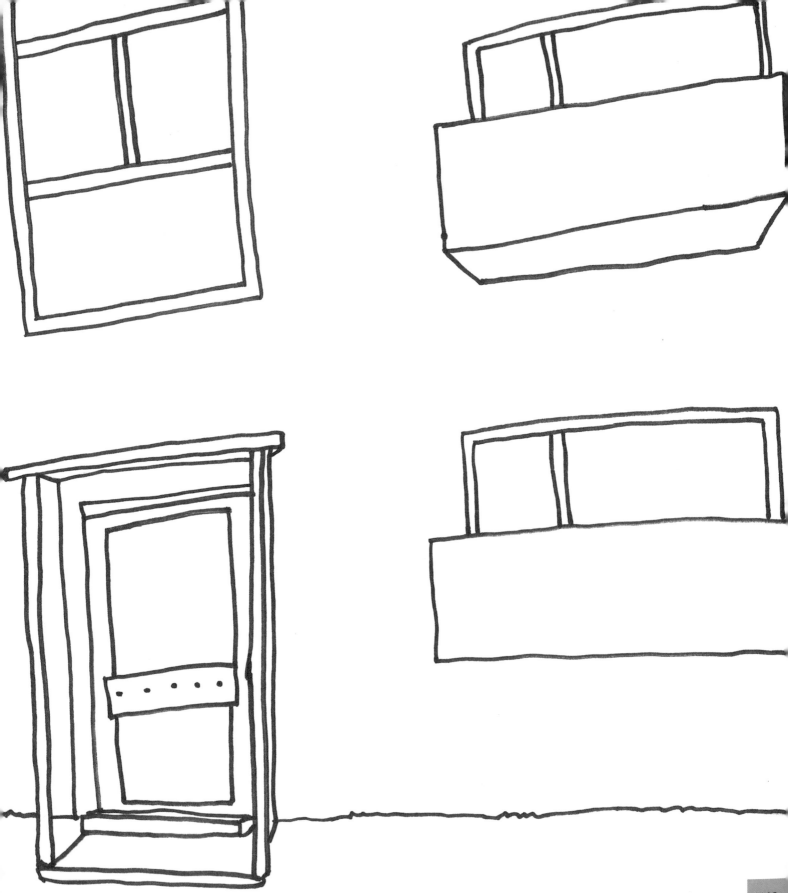

FILL THESE BEDS

Fill these raised beds with color, pave the ground, and paint the walls and door.

HANG A HAMMOCK

Relax in a gently swinging hammock in your sun-filled garden. But what is it swinging from?

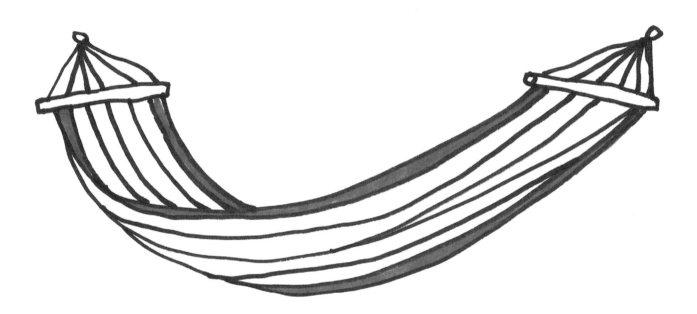

DREAM, DRAW, DESIGN YOUR OWN GARDEN!

ACKNOWLEDGMENTS

Researching this book has included the painless task of visiting some inspiring parks and gardens, such as the Chelsea Physic Garden, Capel Manor Gardens, Hughenden Manor, and the RHS Hampton Court Palace Flower Show, as well as simply looking into gardens over walls and hedges. I am grateful for the guidance given by *Garden Design Bible* by Tim Newbury (Hamlyn).

My thanks, also, to Mary Ann Hall and the excellent team at Rockport, including Cara Connors, Marissa Giambrone, and Cora Hawks.

And, most of all, my love and thanks go to Naomi, Esther, and Celia.

ABOUT THE AUTHOR

James Hobbs is a freelance journalist, writer and artist, the author of *Sketch Your World*, the editor of *Discover Art* magazine, and former editor of *Artists & Illustrators* magazine. After leaving art school, he spent six months living in a camper van as he drew his way around England. His freelance journalism career has taken him to publications including the *New Statesman*, the *Guardian*, and the *Art Newspaper*. He is an advisory board member of the network of blogging artists, Urban Sketchers. His work has been sold worldwide, and included in the Jerwood Drawing Prize exhibition. He lives in London with his wife and their two daughters. He can be followed @jameshobbsart and www.james-hobbs.co.uk.